European Photography Award 1985–1994

Deutsche Leasing's Support for the Arts

Edited by
Jean-Christophe Ammann
Andreas Müller-Pohle

Cantz Verlag

This book was published on the occasion
of the exhibition "European Photography
Award 1985–1994" at the Kulturzentrum
Englische Kirche, Bad Homburg v.d.H.,
November 1994.

© 1994 der Buchhandelsausgabe
Cantz Verlag

ISBN 3-89322-676-1

Cantz Verlag
Senefelderstr. 9
73760 Ostfildern
Tel 0711-44 99 3-0
Fax 0711-44 14 579

Die Deutsche Bibliothek –
CIP-Einheitsaufnahme
European Photography Award 1985–1994:
Deutsche Leasing's support for the arts /
[publ. on the occasion of the Exhibition
"European Photography Award 1985–1994"
at the Kulturzentrum Englische Kirche,
Bad Homburg v.d.H., November 1994].
Ed. by Jean-Christophe Ammann;
Andreas Müller-Pohle
[Transl.: Annette Casasus . . .] – Stuttgart:
Cantz, 1994
ISBN 3-89322-676-1
NE: Ammann, Jean-Christophe [Hrsg.];
Exhibition European Photography Award
1985–1994 <Homburg, Höhe>; Kulturzen-
trum Englische Kirche <Homburg, Höhe>

Gesamtherstellung
Dr. Cantz'sche Druckerei

Übersetzungen
Annette Casasus, Göttingen
Pauline Cumbers, Frankfurt am Main
Regine Reimers, Darmstadt

Printed in Germany

Vorwort / Preface

Die Deutsche Leasing AG, ein junges, innovatives Unternehmen, bietet zukunftsorientierte Lösungen für Investitionen aller Art. Kreativität und Offenheit für neue Entwicklungen gehören zu den wesentlichen Erfolgsfaktoren des inzwischen marktführenden Unternehmens, das maßgeblich dazu beigetragen hat, Leasing zu einem volkswirtschaftlich anerkannten Investitionsinstrument zu machen.

Vor diesem Hintergrund ist auch das Kulturengagement der Deutschen Leasing AG zu sehen. Den Beginn machte 1974 zunächst ein Grafikwettbewerb, später ein Fotowettbewerb an deutschen Kunsthochschulen. 1985 wurde schließlich der "Award for Young European Photographers" ins Leben gerufen – ein Preis, der nicht ohne Widerspruch blieb, war er doch einer jungen und bis dato nicht unumstrittenen künstlerischen Disziplin gewidmet. Daß dieser Vorstoß gleichwohl lohnend war, bestätigt sich nicht nur in der generellen Anerkennung, die die künstlerische Fotografie im Laufe der vergangenen zehn Jahre gefunden hat; es zeigt sich auch darin, daß der Preis seine – durchaus willkommenen – Nachahmer gefunden hat.

Der "European Photography Award", wie er seit 1991 heißt, wurde im Laufe der Jahre immer wieder an veränderte Gegebenheiten angepaßt. Dabei haben wir uns stets des Rats renommierter Fachleute versichert. Besonders hervorheben möchten wir Andreas Müller-Pohle, der den Preis von Anfang an begleitete und dessen Handschrift in der Konzeption unverkennbar ist, ferner Peter Weiermair vom Frankfurter Kunstverein, die Juroren und Kuratoren aus Ost und West und natürlich die Künstlerinnen und Künstler. Ihnen allen danken wir für ihre gestaltende und anregende Mitarbeit an diesem Projekt. Und nicht zuletzt Prof. Dr. Albrecht Dietz, dem ehemaligen Vorstandsvorsitzenden, der das Kulturengagement der Deutschen Leasing AG initiierte und nachhaltig prägte.

Das vorliegende Buch und die ihm zugrundeliegende Ausstellung sind Bestandsaufnahme und Bericht über ein Jahrzehnt kontinuierlicher Förderung der zeitgenössischen europäischen Fotografie. Es gehört zum Selbstverständnis der Deutschen Leasing AG, ihre kulturelle Verantwortung in unserer Gesellschaft auch in Zukunft aktiv wahrzunehmen.

Horst Figge
Sprecher des Vorstandes
Deutsche Leasing AG

Deutsche Leasing AG, a young, innovative company, offers future-oriented possibilities for all kinds of investment. Creativity and openness to new developments are major factors in the success of this firm, which now leads the market and has helped significantly to make leasing an economically established form of investment.

These qualities also form the background to Deutsche Leasing's commitment to cultural sponsorship, which began in 1974 with a graphics competition at German art academies; later it organised a similar competition for photography. In 1985 the "Award for Young European Photographers" was established – a prize that was not without its detractors, dedicated as it was to a developing and still controversial artistic discipline. That this venture was indeed worthwhile has been confirmed not only by the general recognition accorded to art photography during the last ten years; it is also attested by the fact that the prize has found several – entirely welcome – imitators.

The "European Photography Award", as it has been known since 1991, has changed a number of times over the years to suit different circumstances. In making these changes we have always secured the advice of renowned experts. We are especially indebted to Andreas Müller-Pohle, who has been associated with the prize since the beginning and whose influence in its conception is unmistakable. Our gratitude also goes to Peter Weiermair of the Frankfurter Kunstverein, the jurors and curators from Eastern and Western Europe, and of course the artists themselves for their advice and enthusiastic cooperation on this project. Last but not least we wish to thank Prof. Dr. Albrecht Dietz, former chairman of the board, who initiated and vigorously supported Deutsche Leasing's program of cultural sponsorship.

In this book and the exhibition around which it is conceived we evaluate and report on more than a decade of continuous support of contemporary European photography. For the future as well, Deutsche Leasing AG feels the active fulfilment of its cultural responsibility to be part of its role in our society.

Horst Figge
Chairman of the Board
Deutsche Leasing AG

EINFÜHRUNG / INTRODUCTION

DER EUROPEAN PHOTOGRAPHY AWARD hat in den zehn Jahren seines Bestehens manche Veränderung erfahren – hinsichtlich seines Namens, seiner Ausschreibungsform, seiner Dotierung –, doch das Konzept des Preises blieb unverändert: (1) die Orientierung auf Europa, (2) die Konzentration auf junge, zeitgenössische Fotografie und (3) sein Bekenntnis zur Kunst. Dieser letztgenannte Aspekt will betont sein, meint "Kunst" hier doch eine kritische Strategie, die auch auf die angewandten und populären Formen der Fotografie zugreift und etwa die Werbe-, Reportage- oder Knipserfotografie nicht ausgrenzt, sondern auf jeweils spezifische Weise integriert.

Vor diesem qualitativen, weitgefaßten Begriff von Kunst ist der vorliegende Band zu sehen, der die zurückliegenden neun Jahre des European Photography Award dokumentiert. Er versammelt neue Arbeiten von 27 Fotografinnen und Fotografen, die seit 1985 als Preisträger ausgezeichnet wurden. Nicht immer fügen sich diese neuen Werke in den Stil ihrer preisgekrönten Vorgänger. Zwar findet, wer den European Photography Award über die Jahre aufmerksam verfolgt hat, auf den kommenden Seiten manche Déjà-vus, doch ebenso zu finden sind der stilistische Bruch, die Kehrtwendung, der Neubeginn. Indes, bis auf einen Preisträger, den Tschechen Roman Muselík, haben alle in der einen oder anderen Form am Medium Fotografie festgehalten und ihre Arbeit mit und an der Fotografie fortgesetzt.

Die Portfolios auf den folgenden Seiten werden jeweils durch einen kurzen Text eingeleitet, den die Künstlerinnen und Künstler selbst beizusteuern gebeten wurden, um möglichst authentisch zu dokumentieren, wie diese ihre Arbeit verstehen oder, durch Autoren ihrer Wahl, verstanden wissen wollen. Dem Hauptteil vorangestellt ist eine Exkursion in die mannigfaltigen Verzweigungen des fototheoretischen Diskurses der 80er und 90er Jahre von Hubertus von Amelunxen, der neben europäischen Quellen auch die in den USA geführte Debatte einbezieht; den Abschluß des Bandes bilden Biografien der Künstler sowie eine Chronik des Preises.

JEAN-CHRISTOPHE AMMANN
ANDREAS MÜLLER-POHLE

IN THE TEN YEARS since it was established, the European Photography Award underwent a number of changes – with respect to its name, the amount of prize money, and the form in which entries are invited. The concept behind the prize, however, remained unchanged: (1) the orientation towards Europe, (2) the concentration on young, contemporary photographers, and (3) its dedication to art. This third aspect deserves special emphasis, for here "art" means a critical strategy that also takes account of applied and popular forms of photography: it does not exclude advertising, reportage, or "everyday" photography, but integrates them each in a specific way.

This broad, qualitative concept of art sets the tone for the present volume, which documents the past nine years of the European Photography Award. It brings together recent work by 27 photographers who have been prizewinners since 1985. Some of these recent works have little in common stylistically with their prizewinning predecessors; while those who have followed the European Photography Award attentively over the years will often experience *déjà-vu*, just as often they will find a stylistic break, a *volte-face*, a new beginning. Nevertheless, all prizewinners but one, the Czech Roman Muselík, have stayed with the medium of photography in one form or another and have continued their work with and on photography.

The following portfolios are introduced by short texts, contributed at our request by the artists themselves in order to document as authentically as possible how they understand their work, or, through authors of their choice, how they wish their work to be understood. The volume begins with an excursion, by Hubertus von Amelunxen, through the manifold ramifications of the theoretical discourse surrounding photography in the 1980s and 90s, which incorporates European sources as well as the debate carried on in the United States. The book concludes with biographies of the artists and a chronology of the prize.

JEAN-CHRISTOPHE AMMANN
ANDREAS MÜLLER-POHLE

Unterwegs zur Fotografie

"Wenn ich sehe, wie ein Hund Pipi auf der Straße macht, so kann ich das zwar verschieden interpretieren, aber nicht in dem Sinne, daß es ein Bild wäre, wo ein Mann eine Frau vergewaltigt. Bei der Kritik der Konnotation handelt es sich darum, die Grenzen der Konnotation darzustellen." – Vilém Flusser

Zeit, Licht, Ausrahmung. Eine weiß verputzte Mauer, vielleicht in einem Cottage, ein weißer Lichtschalter mit zwei Tasten, von einem weißen, floralen Ornament umrankt. Die funktionale Nüchternheit des Kippschalters kontrastiert auf den ersten Blick mit seinem blumigen und kitschigen Futteral; aber nur auf den ersten Blick, denn beides ist Massenware, millionenfach reproduziert. Dennoch fügt sich der Schalter nicht ganz in die Fassung ein; während er sie bauchig an den Seiten fast überbordet, läßt er oben und unten freien Raum und bei näherem Hinsehen wirkt er ärgerlich schief, was aber auch nur eine optische Täuschung sein kann, die von den beiden Befestigungsschrauben herrührt. Die Kippschalter sind jeweils auf "An" und "Aus" gestellt, funktions- und bildgerecht. Die Irritationen werden mächtiger, je länger ich diese Fotografie betrachte. Martin Parr betitelt sein Bild von 1992 *Signs of the Times*. Es ist wie ein Kribbeln in den Fingern, dieser Drang, sich der Zeit-Zeichen zu bemächtigen, einzugreifen und das Licht zu löschen, dem Bild gewissermaßen seine Berechtigung zu entziehen. Aber Ursprung und Ende liegen versiegelt im Augenblick der Aufnahme, und jede Berührung ist ebenso obsolet wie hier die Natürlichkeit, die Originalität der domestizierten Flora. Die streng orthogonale Aufsicht, die Symmetrie der Schalter, ihre feinen Schatten, die wie Segel im Wind eine Bewegung suggerieren und den Blick auf einer imaginären Diagonale zur rechten oberen Bildecke führen, die ganze Komposition des Bildes leitet den verunsicherten Blick zu dieser Ecke, die von der linken unteren Ecke eines alten lackierten Holzrahmens eines uns verborgenen Bildes ausgefüllt ist. Die äußerste Ecke, dort wo die Hölzer zusammengefügt sind, wirkt leicht angestoßen, als wäre der Lack abgeplatzt; sie ist es aber, die wie ein Vektor auf den fast makellosen Schalter verweist. Die Zeichen der Zeit sind in die Funktionale gerutscht. Die Ordnung der Dinge läßt sich nur im Detail erschließen. Mit einer Formulierung von Jacques Derrida zur Schrift ließen sich die vielen Verschachtelungen in der Fotografie von Martin Parr umschreiben: "Sie [die Fotografie] kommt nur an, um zu erlöschen."

"Ich weiß", schrieb Michel Foucault 1982, "daß es sich nicht gehört, eine Fotografie zu erzählen." Wenn wir glauben, daß Erzählungen und Geschichte heute nicht mehr binden und uns weder einer Zukunft zuzuführen vermögen noch Aufschluß über unsere Gegenwart geben, um so eindringlicher vielleicht ist dann das Verlangen, eben dort eine Erzählung zu beginnen, wo sie in unserer Anschauung ein Ende gefunden hat – in der Fotografie. Aber man zögert, bezweifelt, die Fotografie retrospektiv in der Sprache einholen zu können, schreckt zurück vor Begriffen, die in der Geschichte gewachsen sind und diesem ahistorischen Verbund von Licht, Träger und Referenten nicht gerecht werden können. Unser Begehren fällt zurück in die Sprache. Die Schriftbilder von Eva Schlegel (*Ohne Titel*, 1993) bieten den Anblick einer unmöglichen *Kryptografie*. Die Schrift ist aus dem Fokus, nur in ihrer Übersetzung von der Linearität *in* und *auf* die transparente Fläche gewinnt der verschwommene Schriftgrad das Szenische einer vorstellbaren, aber niemals verlautbaren Lektüre. Als Schrift *und* als Fotografie sehen wir nur noch Strukturen des Restes, einer irreduziblen Spur.

Sprache blendet sich in die Fotografie ein, und der Diskurs über Fotografie – so er nicht der akademischen Gefälligkeit erliegt – wird auch als ein sprachkritischer begriffen werden müssen. Neben den die Fotografie umzingelnden Beschreibungen, die versucht sind, die stilistische Ausprägung des Bildes kunsthistorisch zu kanonisieren, gibt es eine diskursanalytische Kritik der Fotografie, die das Medium Fotografie im Medium Sprache zu reflektieren sucht: Kunstkritik heute ist Medienkritik, ist Kritik der *Techno-Imagination* (Flusser) und wird daher nur im Ansehen der medientechnischen Artikulationen, also intermedial formuliert werden können (Schrift, Fotografie, Film, Fernsehen, Video). Nach wie vor aber sollte das Schreiben über Fotografie – und damit die Entwicklung der begrifflichen Rede – eine Herausforderung bedeuten. Auch eingedenk der 'Rückschläge', die mit der fortschreitenden Musealisierung und damit Historisierung der Fotografie einhergehen, zielt die diskursanalytische Theorie der Fotografie nicht auf die mit der traditionellen Hermeneutik verbundenen Werte wie Sinn, Originalität, formale Einheit oder künstlerisches Schöpfertum, sondern untersucht die Regulative der intermedialen Kommunikation und damit eine medienspezifische Diskursivität. Angesichts der zunehmen-

den *Re-Auratisierung* (Douglas Crimp) der Fotografie, der lupen-bewegten Spezialisten (*Connaisseurs*), die in den Museen die *Vintage prints* horten und die Instanz des Autors wieder in ihre zweifelhaften Rechte setzen, ist eine Fotokritik als Kunst- und Medienkritik gefordert, die auf der Schwelle bleibt vor dem neu-erlich stark frequentierten "Bordell des Historismus". Die Be-denken Foucaults, eine Fotografie zu erzählen, entspringen einer Anschauung, die im diskursiven Geflecht der Fotografie das Er-eignishafte wie auch die Potentialität des Anderen sieht. Denn entweder erzählt die Fotografie nichts und unsere Erzählung ver-ändert sie; sollte sie aber etwas erzählen, so benötigt sie die Rede nicht – und das Geschwätz wird unerträglich.

Wir mögen eine Fotografie bedrängen, endlich ihr Schwei-gen preiszugeben und als entbundenes Wort in unsere Zeit hin-einzureichen, wir mögen ihr in der ganzen Macht unserer be-zeichnenden Willkür eine Geschichte widerfahren lassen, deren fotografische Verdichtung sie wäre, wir können lachen oder wei-nen an ihrer Statt – alles nur, um uns dem Bild irgendwie anzu-verwandeln ("einzumummeln" hatte Benjamin einmal geschrie-ben) und uns vielleicht eben dem Blick auszusetzen, in dessen Visier das Gesehene fotografisch arretiert wurde. Der Schweizer Fotograf Beat Streuli späht voyeuristisch mit einem Teleobjektiv die Masse aus und läßt seinen Apparat Frauen fixieren. Was wir sehen, sind die Gewalt und der Exhibitionismus seines apparativ maskierten Blicks. Das *skopische Regime* (Christian Metz) ist vom männlichen Blick determiniert, der im Bild posiert.

Allen Bestrebungen, mimetisch einer aus dem raumzeitli-chen Kontinuum entfernten Blickkonstellation habhaft zu wer-den, geht die gewöhnliche Einsicht voraus, daß die Sprache das, was wir Ähnlichkeit nennen, ausschließt und in Symbole bannt, die Fotografie hingegen im betörenden Maße im Netz der Ähn-lichkeit verstrickt ist. Wollten wir also eine Fotografie erzählen und unsere verspäteten Worte in den Schatten des gewesenen, des verblichenen Lichtes des Bildes stellen, dann lassen wir uns auf ein Spiel von Korrespondenzen ein. Sie unterliegen einer kontextuell gebundenen hierarchischen Ordnung, innerhalb de-rer Bedeutungen vom Diskurs zum Bild oder vom Bild zum Dis-kurs sich bewegen. Daß ein Text einer Fotografie (oder einem Gemälde) entspräche, ist ein Ausdruck der imaginären Bemäch-tigung, dessen Objekt – *spektrum* würde Roland Barthes sagen – immer nur die geisterhafte Erscheinung eines Entzugs sein wird. Mit der Sehnsucht nach einem Diskurs *über* das Bild, der kein anderer wäre als der Diskurs *des* Bildes (Louis Marin), bleiben wir unterwegs.

Wegweisend also sollte das Mögliche sein, die *Potentialität*, den Diskurs nicht als eine Lichtung im Sinne einer Bergung oder Hervorkehrung eines Sinnes, einer Bedeutung zu suchen, sondern als eine Bewegung, der die vorübergezogene Erschei-nung des Abgebildeten ebenso innewohnt wie ihre vollendete und irreversible Endlichkeit. "Das Klischee", schrieb Jean-Fran-çois Lyotard 1984 zu den fotografischen Arbeiten von Monory, "selbst in einer 1/500 Sekunde aufgenommen, läßt uns keines-wegs in dem Augenblick leben, es führt in eine Zeitlichkeit ein, die auch nicht die der Substanzen, der objektiven Gegenstände ist, sondern eine Zeitlichkeit 'ohne Verstreichen', ohne ein Vor-her oder Nachher, in einem großen multi-ästhetischen Block kondensiert, die ihre Wirkungen nicht innerhalb der Möglich-keiten des *Noch-Nicht* und des *Nicht-Mehr* entfaltet, sondern sie alle zusammen, miteinander unverträglich in der Schwebe hält."

Der apparative Ursprung des Bildes muß als ebenso signifi-kativ erfaßt werden wie sein dispositives Erscheinen (die räumli-che beziehungsweise gesellschaftliche Struktur, kraft derer Pro-duktion und Rezeption des Bildes in eine produktive Differenz zueinander gesetzt werden). Das fotografische Dispositiv fragt danach, in welchen Räumen welche und wessen Blicke sich kreuzen, verpassen, oder wer sich wessen Blick aneignet. Das Po-tential der Fotografie beinhaltet sowohl die Technizität des Me-diums wie die – museologisch-museografischen – Strategien der Verleugnung dieser Technizität. Die fotografischen Inszenierun-gen von Henrik Duncker und Yrjö Tuunanen, im Leben erkalte-te Tableaus der Inversion von Innen und Außen, führen den Be-trachter in eine 'Pose des Einklangs'. Ein bürgerliches Interieur, eine ältere Dame blickt in ihrem Sessel sitzend über das Objek-tiv hinweg, sie träumt einen Tagtraum. In geisterhaften Erschei-nungen findet sie ihre Gesellschaft, der einem Salon des 18. Jahr-hunderts entliehene Violinist begleitet die Erinnerung vielleicht an ihre Herkunft, an das elterliche Paar links im Bild. Aber nicht die Geister – was könnte der Fotografie denn ursprünglicher sein als die Geisterwelt – verrücken die geordnete Welt der Re-präsentation, sondern die strenge Geometrie der Blicke. Wäh-rend die Blicke des Geisterehepaars den Raum diagonal durch-queren, um im Spiegel paradoxal sich ihrer Anwesenheit als *Wiedergänger (revenants)* zu versichern, schauen wir, in der Auf-sicht perspektivisch geführt, über die träumende Frau hinweg geradezu in das Bullauge einer Waschmaschine hinein. In dieser vielleicht "visualistischen" (Müller-Pohle) Fotografie wird der Raum von den Blicken rhythmisiert, und nur die bereits doppelt erlöschten finden ihre Entsprechung im (Spiegel-) Bild.

Zu den Fragen des Diskurses über Fotografie werden also gehören, wie unsere Begegnung mit ihr verläuft, welchen Inten-tionen unser Blick (unsere "Aufsicht") unterliegt und wie wir sprachlich über das, was in der Fotografie dem Projekt einer Ge-

genwart entglitten ist, verfügen wollen oder können. So geht es in der Fotografie um die Singularität, die wir linguistisch zu formulieren suchen, der im Zuge der Benennung, der sprachlichen Geste a posteriori, eine Andersheit hinzugefügt wird, welche zu begreifen das Fotografische uns einlädt. Jeder Kanon, so Harold Bloom, geht immer auf Kosten einer Gegenwart. Nun steht die Theorie aber – und mit Theorie verbinden wir gemeinhin eine Anschauung, die, begrifflich gefaßt, einen überindividuellen Konsens gründen möchte – vor dem Problem, die Eigenart der Fotografie als *Emanation des Referenten* (Barthes) oder als *Stabilisator des Referenten* (Lyotard) mit dem der telematischen Gesellschaft eigenen *Verschwinden des Referenten* (Virilio) in ein Verhältnis setzen zu müssen – den Geistern der anderen Generation von Duncker und Tuunanen oder den einst realen, aber heute unwirklich, filmisch und unheimlich wirkenden Flotten von Erasmus Schröter. Gerade jetzt, da die Ära der 'klassischen' physiko-chemischen Fotografie wenn nicht ihrem Ende zugeht, so doch mitten in der Phase der Übersetzung von der analogen zur digitalen Bilderwelt steht, ist es unsere Aufgabe, nach einem Verständnis für die Fotografie zu suchen. Die Bezugspunkte, die Rahmenleisten der Referenz, haben sich während der letzten Jahrzehnte merklich verschoben. Die "Fotografie nach der Kunstfotografie" (Solomon-Godeau) beziehungsweise die "Fotografie nach der Fotografie" markieren heute den anderen Kontext unserer Kritik.

Es sind zweifellos die Arbeiten von Roland Barthes gewesen, die seit den 60er Jahren bis heute den theoretischen Diskurs über Fotografie entscheidend geprägt haben. In seinem Essay *Die fotografische Botschaft* hatte Barthes 1961 die "Koexistenz von zwei Botschaften" als das eigentliche "fotografische Paradox" bezeichnet: die kulturell verankerte "konnotierte (oder codierte) Botschaft" (der Stil, die Rhetorik des Bildes etc.) entwickelt sich "von einer Botschaft ohne Code her" (das fotografische Analogon). In seiner berühmten Interpretation der Panzani-Reklame von 1964 (*Die Rhetorik des Bildes*) heißt es: "Nur der Gegensatz zwischen dem kulturellen Code und dem natürlichen Nicht-Code kann dem spezifischen Charakter der Fotografie Rechnung tragen und die anthropologische Revolution würdigen, die die Fotografie in der Menschheitsgeschichte auslöste. Die bewußte Reaktion, die eine Fotografie auslöst, hat in der Geschichte kein Vorbild. Sie erzeugt nicht das Bewußtsein des *Daseins* des Gegenstands (das eine Kopie auslösen könnte), sondern des *Dagewesenseins*. Wir stoßen hier auf eine neue Kategorie des Raum-Zeit-Verhältnisses: räumliche Präsenz bei zeitlicher Vergangenheit, eine unlogische Verbindung des *Hier und Jetzt* mit dem *Da und Damals*."

Diese 'unlogische Verbindung', die Barthes zum Gegenstand seines letzten Buches *Die helle Kammer: Bemerkung zur Photographie* (1980/1985) machen sollte, dieses "Es-ist-gewesen" ist jeder Betrachtung der Fotografie ursprünglich – egal, ob ihr Verlangen sich kriminologisch, kunstkritisch, konsumtiv oder als ein 'reines' Begehren begründet. Die Schriften von Roland Barthes, und in den 70er und 80er Jahren von so unterschiedlichen Autorinnen und Autoren wie Michel Foucault, Jacques Derrida, Julia Kristeva, Christian Metz, Jean Baudrillard, Vilém Flusser, Jean-François Lyotard oder Paul Virilio, haben einen wesentlichen Anteil an der Entwicklung einer kritischen Theorie der Fotografie gehabt (ich spreche hier ausdrücklich nicht von den sicherlich ebenfalls relevanten theoretischen Entwürfen, die aus der Fotokritik selbst kommen, die also ihr eigenes Genre reflektieren). Indem sie die Fotografie in einen erweiterten Schrift- und Textbegriff fassen, haben sie explizit oder implizit der Fotografie Wege gebahnt, die ihr Zugänge zu allen menschlichen und gesellschaftlichen Bedeutungssystemen eröffnet haben. Viele der wichtigen Impulse kamen also auch in dieser Zeit nicht aus einem traditionellen Bild- und Künstlerbegriff weiterhin verhafteten Kunstwissenschaft, sondern aus den offenen Bereichen der Semiotik, der Diskursanalyse, der Psychoanalyse und des Poststrukturalismus. Zudem unterliegen diese theoretischen Ansätze in einem entscheidenden Maße einer wiederum eigenen Entwicklung, die sich in dem jeweiligen kulturellen und ideologischen Kontext ihrer Rezeption bekundet. So hat beispielsweise die angelsächsische Rezeption der wichtigen Schriften von Foucault, Kristeva, Barthes und Derrida im Rahmen neuerer akademischer Ausrichtungen wie *Visual Anthropology*, *Cultural Studies* oder der *Gender Studies* durch Laura Mulvey, Homi K. Bhabha, Jane Gallop, Norman Bryson, Stephen Bann, John Tagg, Victor Burgin, Allan Sekula, Rosalind Krauss und viele andere eine bedeutende Übersetzung in andere soziokulturelle Kontexte erfahren, die nun von Umweg zu Umweg – und immer dezentriert – sich den ursprünglichen Texten hinzufügt und wesentlich am fototheoretischen Diskurs teilhat.

Ein so einfacher wie grundlegender Beitrag besteht in dem Begreifen der Fotografie als einem visuellen Ausdruck innerhalb eines intertextuellen Gefüges, das die Grenzen des fotografischen Werks löchert und durchlässig macht. Die Fotografie selbst wird zu einem Gebilde, das trotz seiner medientechnisch bedingten Abgeschlossenheit, trotz seiner sozialökonomischen und kulturellen Bestimmungen, in immer neuen – realen oder imaginären – Kontexten einem Wandel von Bedeutungszuweisungen unterliegt. Ein Beispiel des englischen Künstlers und Theoretikers Victor Burgin mag den Begriff der *Intertextualität*

erläutern: "[. . .] das einfachste [Beispiel] ist das einer Getränkewerbung, die einen mit Eiswürfeln und einem Schuß Wermut gefüllten gläsernen Pumps zeigt; ob es mir nun bewußt ist oder nicht, stelle ich augenblicklich Bezüge her zu: 'Aschenputtel' (sagenhafter gesellschaftlicher Aufstieg; romantische Liebe); 'aus Damenschuhen trinken' (*fin-de-siècle*, playboys und Ballettmädchen; körperliche Liebe); 'Amerikanisch-Sein' ('on the rocks' – zum Beispiel Szenen aus amerikanischen Streifen des B-Films, in denen zu den Klängen des Barpianos getrunken wird); 'Ausgesetztsein' (Eisberge; die durchsichtige Kälte der Polarmeere); und vieles mehr. All dies gehört in den Bereich, den Barthes als das '*déjà-lu*' bezeichnet: das 'schon Gelesene', 'schon Gesehene', alles, was wir bereits wissen und kennen, und was der Text daher heranziehen oder 'aus Versehen' heraufbeschwören kann."

Die Pluralität von Bedeutung verhindert nicht nur eine das Werk erschöpfende Lektüre, sie ermöglicht auch die kritische Auflösung festgelegter Schemata der Bedeutung. Sobald das Werk selbst (oder sein Schöpfer) als Souverän der Bedeutung wie der Herrscher über das Volk entmachtet ist, findet seine Auslegung im gesellschaftlichen Raum statt und der Struktur des fotografischen Bildes werden eine Vielzahl heterogener Diskurse zugeordnet. Die sozialökonomischen, kulturellen und nunmehr auch akademischen Einbindungen und Definitionen der Fotografie als eigene Genera der wissenschaftlichen Fotografie, der Illustrations- oder Dokumentarfotografie, der privaten Fotografie, der kommerziellen Atelierfotografie, der Kunstfotografie oder der experimentellen Fotografie . . . sind heute nicht mehr tragfähig (und wie findig muß der Connaisseur jetzt sein, um erotische oder pornografische Fotografie als weitere Klassen einzurichten). Die Demarkationslinien zwischen den Genera der Fotografie sind im kommerziellen wie im künstlerischen Bereich (und auch hier wird eine Scheidung nur willkürlich erfolgen können) aufgelöst oder werden in die Obhut ihrer professionellen Sekundanten gelegt – der Museumskuratoren, Kunstkritiker, Informatiker und Werbestrategen.

"Die Theorie der Fotografie", schrieb Wolfgang Kemp in Voraussicht der Entwicklung nach 1980, könnte legitimiert sein, "sich zugunsten einer Theorie der Erfahrung aufzulösen." In der Tat hatte Roland Barthes bereits in den 70er Jahren begonnen, seine semiotischen Lektüren der Fotografie durch phänomenologisch begründete zu 'ergänzen', wobei diese folgerichtig nicht mehr im Einklang mit den ersteren standen. Roland Barthes hatte in *Die helle Kammer: Bemerkung zur Photographie* für die Betrachtung der Fotografie zwischen zwei Ebenen der Bedeutung unterschieden. Im *studium* begegnen wir dem Bild mit einem durch eine ethische und politische Kultur geschulten Interesse

und versuchen, über eine kulturell und kontextuell mehr oder minder stark gebundene Sichtweise zu einer Deutung zu gelangen, die der Intention des Bildes (oder dem Auftrag des Fotografen oder der Fotografin) annähernd entsprechen könnte. Unsere Erfahrung hätte sich also damit zu begnügen, die Botschaft des Bildes erschöpfend zu bemessen und das in ihm enthaltene weitere Potential an Bedeutung anzuhalten, auszusetzen und zu arretieren. (Burgin hat zu Recht darauf hingewiesen, daß im *studium* Bedeutung "verhaftet" wird, "im Namen einer erfahrenen Gewißheit"). Für das *studium* einer Fotografie müssen wir also vor allem durch Wissen befähigt sein, das heißt durch die Beherrschung des ideologischen wie kulturellen Codes. Für das *punctum* verschieben sich die Vektoren des Blicks, seiner Ausrichtung und seiner Absicht. Barthes wählte diesen Begriff, diesen Namen, um das Mal zu bedeuten, das eine Fotografie beziehungsweise ein Detail der Fotografie im Betrachter hinterlassen kann. Im *punctum* geht etwas aus dem Bild hervor und punktiert, durchlöchert den Diskurs der Beherrschung, oder, wie Derrida bemerkt, "ein Punkt der Singularität durchlöchert die Oberfläche der Reproduktion – und sogar der Produktion – von Analogien, Ähnlichkeiten und Codes." Was im *punctum* uns betrifft ist die "absolute Singularität des Anderen", die nahbar nur in ihrem Verschwinden ist. Der Referent ist dagewesen, entzieht sich aber, fortwährend wiederkehrend, für immer seiner und meiner Präsenz.

Die großformatigen Tableaus von Marc Viaplana und Mabel Palacín von 1992/1993 tragen einen Titel, der in all seinen Variationen die Arbeiten selbst wie auch das Fotografische in nicht endenden Anläufen skandiert. Die *Suite de las desapariciónes* suggeriert mit den je 6 mal 4 oder 5 mal 4 zu einem Tableau vereinten Bildern eine Folge verschwindender Erscheinungen. In Parenthese gesetzt lautet der weitere Titel: *(What has never been cannot end)*, und jedes Bild fügt sich als musikalische Variation eines "movimiento" in eine kontrapunktische Komposition der immer wieder aufgeschobenen Klänge des Verendens. Projektile, die ihre Flugbahn bereits hinter sich haben und durch das Ziel unterschiedlich deformiert sind, werden, von Daumen und Zeigefinger (Index) gehalten, vor der Kamera wie vor einem Zeugen oder dem Gerichtsstand exponiert. Die Geschosse sind aufgetroffen, haben vielleicht eine Oberfläche durchbohrt und liegen nunmehr als bloße Indizien vor. Das Gewesene – der Grund, die Absicht, das Zielen und Visieren, der Schuß, die Verletzung, der Tod – erreicht uns als Projektil, mit seinem äußersten Ende, jener einförmigen Spitze, die zuerst das Andere berührte und vielleicht vernichtete. Zu dieser Folge der "movimientos" zählt auch eine Reihe von Porträts, Menschen, deren Antlitz wie von

einem Moiré überzogen, punktiert erscheint, unwirklich wie Boltanskis Grabmale der Geschichte, aber real in seiner ganzen Abgeschiedenheit. *Nichts* ist verschwunden. Die Arbeiten von Viaplana und Palacín – und dies gilt im weiteren Kontext ebenfalls für die Körpermale von Thomas Florschuetz (*Plexus*) – verdichten die Frage nach dem Referenten. Nicht das Verschwinden, sondern die verzogene Präsenz, der aufgeschobene Tod, markieren diese Fotografien – *(What has never been cannot end)*. Der amerikanische Kunstkritiker Craig Owens hatte eben in der Problematisierung des Referenten das Neue in der postmodernen Fotografie gesehen. In seiner Lektüre des letzten Buches von Barthes hebt Derrida die Bedeutung des Referenten beziehungsweise der Referenz hervor:

"Es ist die moderne Möglichkeit der Photographie (ob Kunst oder Technik ist hier unwichtig), die den Tod und den Referenten in einem System miteinander verbindet. Das geschieht nicht zum ersten Mal, und diese Verbindung, die einen wesentlichen Bezug zur Reproduktionstechnik, zur Technik schlechthin hat, hat nicht auf die *Photographie* gewartet. Aber der unmittelbare Beweis dafür, den das photographische Dispositif liefert, oder die Struktur des *Restes*, den es zurückläßt, sind irreduzible, unbestreitbare originelle Elemente. Das bedeutet das Scheitern, oder zumindest die Grenzen alles dessen, was in der Sprache, in der Literatur und in den anderen Künsten irgendwelche grobschlächtigen Theoreme über eine generelle Entwertung des *Referenten* oder dessen zu begründen schien, was in manchmal karikaturhafter Vereinfachung unter diesen weiten und vagen Begriff subsumiert wurde. Zumindest in dem Augenblick aber, wo das *punctum* den Raum zerreißt, machen die Referenz und der Tod gemeinsame Sache mit der Photographie."

Täuschen wir uns nicht, lassen wir uns von den Geistern nicht in die Irre führen, denn nicht die Referenz auf das Reale verschwindet, vielmehr hat uns das Dispositif der Fotografie dazu aufgefordert, die Paradoxien in der *Bezeugung* des Realen zu bedenken. Darin liegt das Bizarre des Mediums Fotografie, seine *halluzinatorische Wirkung* (Barthes), daß es falsch auf der Ebene der Wahrnehmung ist, aber wahr auf der Ebene der Zeit. Damit ist die Fotografie nicht einer Beliebigkeit preisgegeben, wie es manche vermeinen, sondern offen und verbunden mit der Arbeit am Referenten, ob dieser nun im kunsthistorischen, politischen oder kulturellen Bereich liegt. Unsere Aufgabe liegt in der Übersetzung der fotografischen Repräsentation in unsere Zeit: diesem Entsetzen, das dem Gewesenen entspringt, haben wir in der Kritik zu entsprechen. Entwertet aber wird der Referent, wenn er als Stilmittel einer Tradition überantwortet wird und dem musealen Index einzig noch als Nachweis dient. Im Museum werden die Einschnitte in die Zeit aufgebahrt und von Floskeln umsäumt wie Martin Parrs Lichtschalter vom floralen Kitsch. Einem solchen Flickwerk konnte man in der Ausstellung *Photography Until Now* begegnen. John Szarkowski verabschiedete sich im Jubiläumsjahr der Fotografie, 1989, von seiner langjährigen Kuratorentätigkeit (seit 1962) am Museum of Modern Art mit einem Gang durch die Bildergalerie der Fotografie von Talbot bis Nicholas Nixon. Ein Ausblick auf die Zukunft beschließt Szarkowskis umfangreiche Kommentare zur Geschichte der Fotografie: "Fotografien sind wesentlich nicht von der Hand, sondern vom Auge gemacht, mit einer Maschine, die mit einer unnachsichtigen Aufrichtigkeit die Qualität des vom Auge unterrichteten Geistes aufzeichnet. Nachgestellte Gedanken, die diese Aufrichtigkeit verschleiern, machen das Bild selten besser. [. . .] Um unnötige Mißverständnisse, insbesondere ihre eigenen, zu vermeiden, ziehen es heute die meisten ambitionierten und hoch talentierten Fotografen vor, für keine instrumentellen Funktionen zu arbeiten – keine 'nutzvollen' Ziele. Sie wünschen sich einfach Bilder zu machen, die – wenn sie gut genug sind – ihre Intuition eines Teils oder Aspekts des alltäglichen Lebens bestätigen." Ein Vergleich der sehr unterschiedlichen Diskurse ist vermessen, ebenso unergiebig wäre es, diesem historisch sachkundigen, überaus elitären Standpunkt einen ideologiekritischen, diskursanalytisch motivierten gegenüberstellen zu wollen. Die fotografische Maschine, so Szarkowski, wäre nur Mittlerin zwischen Auge und Geist, unnachsichtig in ihrer Wahrhaftigkeit, und dem genuinen Schöpfertum der Künstlerin oder des Künstlers untergeordnet – bald, so schrieb Talbot vor 150 Jahren, wird man in der Fotografie wie in der Malerei einen Rembrandt von einem Raffael unterscheiden können.

Diesen Rang hat die Fotografie innerhalb der Schönen Künste nun eingenommen, die Singularität des Fotografischen liegt nicht mehr in der Zeit, sondern in der Signatur. So hat sie einen Diskurs gefunden, der die Blicke *auf sie* und *in ihr* dann verstellt, wenn diese nur mehr im Stil reflektiert werden – eben in der *Aufsicht*. Es muß also geradezu bedenklich stimmen, daß Szarkowski in seine Schau (und sein Museum) neben Rauschenberg und Warhol auch Cindy Sherman aufnahm. Ihr Stil, so lautet das *studium* Szarkowskis, läge in der Selbstinszenierung. . . Wir schließen das mächtige Portal des Mausoleums und bleiben unterwegs zur Fotografie.

Hubertus von Amelunxen

N.B. Ein spiritistischer Fotograf im letzten Drittel des 19. Jahrhunderts antwortete auf die Frage des Richters, ob er denn nun ein Medium sei: "Nein, ich bin nur der Fotograf."

On the Way to Photography

"When I see a dog having a pee in the street I can in fact interpret this in different ways, but not as an image of a man raping a woman. The critique of connotation is concerned with presenting the limits of connotation." – Vilém Flusser

Speed, exposure, framing. A white plastered wall, perhaps in a cottage, a white light switch with two buttons surrounded by a white floral ornament. At first sight the functional sobriety of the light-switch contrasts with its florid and kitschy setting; but only at first sight, for both are mass products, reproduced by the million. Yet the switch does not quite adapt itself to the framework setting; whereas at the sides it almost edges out beyond it in a bulge, at the top and bottom it leaves a free space. And on looking closer it seems annoyingly crooked, which, however, may only be an optical illusion arising from the two screws securing it to the wall. One of the buttons is set at "on", the other at "off", in accordance with the function and the image. The longer I look at this photograph, the more powerful the irritations become. Martin Parr has given this work, which dates from 1992, the title *Signs of the Times*. The drive to seize the signs of the times, to intervene and put out the light, in a sense to take away the photograph's justification, almost makes one's fingers itch. But origin and end lie sealed in the moment of the take, and each and every touch is just as obsolete as is here the naturalness, the originality of the domesticated flora. The strict right-angled camera perspective, the symmetry of the buttons, their fine shadows which suggest movement like sails in the wind and by means of an imaginary diagonal lead our gaze to the top right-hand corner of the photograph. The whole composition of the photograph leads the unsettled gaze to this corner, which is taken up by the lower left-hand corner of an old gloss-painted wooden picture frame, the picture remaining concealed. The outermost corner, there where the wooden pieces are joined together, seems to be slightly damaged, as if the paint has flaked off; but it is this corner which like a vector refers to the almost immaculate switch. The signs of the times have slipped into the functional. The order of things can only be deduced from the detail. A formulation by Jacques Derrida on writing may serve to circumscribe the many convolutions in the photography of Martin Parr: "It [photography] arrives, only to fade away."

"I know", wrote Michel Foucault in 1982, "that it is not fitting to narrate a photograph". If we believe that today narrations, like history, no longer bind us, are no longer able to lead us towards a future or provide information about our present, then the desire is perhaps all the more insistent to begin a narration right there where – in being contemplated by us – it has found an end, namely in photography. But one hesitates, has doubts about being able to catch up retrospectively with photography through language. One recoils in the face of terms which have grown in history and cannot do justice to this ahistorical association of light, carrier and referent. Our desire slips back into language. Eva Schlegel's script images (*Untitled*, 1993) offer us a view of an impossible *cryptography*. The script is out of focus. Only through its transfer from the linear *into* and *onto* the transparent surface does the blurred script-type acquire the scenic character of an imaginable but forever inarticulable reading. As writing *and* as a photograph all we see are the structures of the remainder, an irreducible trace.

Language fades into photography, and the discourse on photography – in as far as it does not accommodate itself to academic usage – will also have to be understood as a critical discourse on language. Alongside the descriptions which encircle photography and which are tempted to make an art history canon of the stylistic form of the image, there is a discourse-analytical critique of photography which attempts to reflect on the medium of photography through the medium of language: today, art criticism is media criticism, is criticism of *techno-imagination* (Flusser). It will, therefore, only be possible to formulate it with regard to media-technical articulations, that is to say, intermedially (writing, photography, film, television, video). However, writing about photography – and with it the development of conceptual terms – should still signify a challenge. And bearing in mind the 'set-backs' which go hand in hand with the progressive move towards museology and thus the historicisation of photography, the analytical discourse of the theory of photography aims not at the values associated with traditional hermeneutics, such as meaning, originality, formal unity or artistic creativity, but rather examines the regulator of intermedial communication and thus a discursiveness specific to media. In view of the increasing *re-auratisation* (Douglas Crimp) of photography, of the scrutinising specialists (connoisseurs) who

stockpile the *vintage prints* in museums and reinstate the instance of the author in his or her own doubtful right, what is required is a critique of photography which is a critique of art and the media, and one which remains on the threshold of the, of late, highly frequented "bordello of historicism". Foucault's reservations about narrating a photograph arise from a view which in the discursive network of photography sees the other both as event and as potency. For either the photograph tells nothing and our narration alters the photograph, or it is supposed to tell something, in which case it does not need speech – and the prattle becomes unbearable.

We may want to put pressure on a photograph to abandon its silence at last and reach into our time as an unbounded word. With the full force of our descriptive arbitrariness we may want to impose a story on it, of which it would be the photographic condensation. We can laugh or cry in its stead – all this, just so as to somehow relate ourselves to (Benjamin once wrote "wrap ourselves up in") the picture and perhaps even to expose ourselves to the gaze, in the visor of which what has been seen was arrested photographically. The Swiss photographer Beat Streuli spies voyeuristically on the masses with a telephoto lens and lets his apparatus fix women. What we see is the violence and the exhibitionism of his gaze which is masked by the apparatus. The *scopic regime* (Christian Metz) is determined by the male gaze posing in the photograph.

All attempts to come to grips mimetically with a visual constellation removed from the time-space continuum are preceded by the common insight that language rules out that which we call similarity, capturing it in symbols. On the other hand, photography is caught up to a dazzling degree in the web of similarity. Thus if we want to narrate a photograph and place our belated words in the shadow of the past, paled light of the image, then we get involved in a play of correspondences. These are subject to a hierarchical, context-bound order within which meanings shuttle to and fro from the discourse to the picture and from the picture to the discourse. That a text should correspond to a photograph (or a painting) is the expression of an imaginary seizure. Its object – Roland Barthes would say *spectrum* – will always be merely the ghostly appearance of a withdrawal. We remain on the way, with the longing for a discourse *about* the image, a discourse which would be none other than the discourse *of* the image (Louis Marin).

Our signpost, therefore, should be the possible, the *potency* of seeking the discourse not as a clearing in the sense of a salvaging or a parading of meaning, of significance, but rather as a movement in which are inherent both the passing appearance of

the depicted and its complete and irreversible finiteness. "The cliché", wrote Jean-François Lyotard in 1984 commenting on the photographic works of Monory, "even when taken at 1/500th of a second, in no way allows us to live in that moment, it leads into a temporality which is also not that of substances, of objective things [. . .], but rather a temporality 'without a lapse', without a before or after, condensed in a large multi-aesthetic block, not unfolding its effects within the possibilities of the *not yet* and the *no longer*, but holding them all together in a balance, incompatible with each other."

The provenance of the photograph from an apparatus must be grasped as being just as significant as the requisites of its appearance (the spatial and/or social structure by virtue of which there is a productive difference between the production and reception of the photograph). The photographic disponer asks in which spaces which and whose eyes meet, let each other slip, or who appropriates whose gaze. The potential of photography entails both the technicity of the medium and the – museological-museographical – strategies of the denial of that technicity. The photographic stagings by Henrik Duncker and Yrjö Tuunanen, tableaux of the inversion of inside and outside grown cold in life, lead the viewer into a 'pose of harmony'. A bourgeois interior, an older woman sitting in her armchair looks beyond the lens and dreams a day-dream. She finds company in ghostly appearances, the violinist, borrowed from an 18th-century salon, accompanies the recollection perhaps to her origins, to the parental couple on the left of the photograph. But it is not the ghosts – for what could be more natural to photography than the world of ghosts – that unsettle the ordered world of representation but the strict geometry of the gazes. While the gazes of the ghostly couple cross the space diagonally so as, paradoxically, to assure themselves of their presence as *revenants* in the mirror, our eyes are led by the camera perspective and gaze beyond the dreaming women directly into the bull's eye of a washing machine. In this perhaps "visualistic" (Müller-Pohle) photograph, space is imbued with rhythm by the gazes, and only those who have already faded out twice find their correspondence in the (mirror) image.

The discourse on photography will have to deal with questions such as: how our meeting with photography proceeds, which intentions our gaze (our "perspective") is subject to, and how we want to or can dispose linguistically of that which in photography has slipped from the project of a presence. Thus photography is concerned with the singularity which we try to formulate linguistically, and to which in the course of naming, of the linguistic gesture a posteriori, an otherness is added which the photographic invites us to grasp. According to Harold Bloom

a canon always exists at the expense of a presence. Now, however, theory – and with theory we generally associate a view which, formulated abstractly, would like to ground a supra-individual consensus – is confronted with the problem of having to place the particular nature of photography as *an emanation of the referent* (Barthes) or as a *stabiliser of the referent* (Lyotard) in relation to the *disappearance of the referent* (Virilio) inherent in a telemetric society – the ghosts of the other generation in Duncker and Tuunanen, or Erasmus Schröter's once real fleets which today seem unreal, film-like and uncanny. Right at a time when the era of 'classical' physic-chemical photography is, if not at an end, then at least in the middle of the phase of its transition from an analogue to a digital world of images, it is our task to seek an understanding for photography. The points of reference, the framework, have shifted noticeably over the past decades. Today the altered context of our critique is marked out by "photography after art photography" (Solomon-Godeau) and/or "photography after photography".

From the 60s to today the works of Roland Barthes have been the ones which have decisively influenced the theoretical discourse on photography. In 1961 in his essay *The Photographic Message* Barthes characterised the "coexistence of two messages" as the real "photographic paradox": a culturally anchored "connoted (or coded) message" (the style, the rhetoric of the image etc.) develops on the basis of "a message without a code" (the photographic analogue). In his famous interpretation of the Panzani advertisement in 1964 (*Rhetoric of the Image*) he writes: "Only the opposition between the cultural code and the natural non-code can take into account photography's specific character and acknowledge the anthropological revolution which photography triggered in the history of mankind. The conscious reaction which a photograph triggers has no model in history. It does not create a consciousness of the *being there* of the object (which a copy could trigger) but of its *having been there*. Here we are confronted with a new category of the space-time relationship: spatial presence and chronological past, an illogical connection between the *here and now* and the *there and then*."

This "illogical connection" which Barthes was to make the subject of his last book, *Camera Lucida: Reflections on Photography* (1980/1985), this "it has been", is at the origin of every consideration of photography – regardless of whether its desire has a criminological, art historical or consumerist basis, or a basis in "pure" yearning. The writings of Roland Barthes, and during the 70s and 80s those of such different authors as Michel Foucault, Jacques Derrida, Julia Kristeva, Christian Metz, Jean Baudrillard, Vilém Flusser, Jean-François Lyotard or Paul Virilio, have made an essential contribution to the development of a critical theory of photography (I am deliberately omitting the equally relevant theoretical drafts which come from the realm of photography criticism itself and which thus reflect on that particular genre). By including it in a broadened concept of writing and text, explicitly or implicitly they blazed new trails for photography which in turn opened up access paths to all human and social systems of meaning. During that period many of the important impulses came not from aesthetics and art history, which are still bound to a traditional concept of the image and the artist, but rather from the receptively open realms of semiotics, discourse analysis, psychoanalysis and post-structuralism. What is more, these theoretical approaches are also subject to a decisive development of their own which is manifest in the respective cultural and ideological contexts of their reception. Thus, for example, within the framework of more recent academic orientations such as *visual anthropology*, *cultural studies* or *gender studies* promoted by Laura Mulvey, Homi K. Bhabha, Jane Gallop, Norman Bryson, Stephen Bann, John Tagg, Victor Burgin, Allan Sekula, Rosalind Krauss and many others, the Anglo-Saxon reception of the important writings of Foucault, Kristeva, Barthes and Derrida has experienced a significant transfer into other socio-cultural contexts which, by a circuitous and more and more decentralised route, is now adding itself to the original texts and making an essential contribution to the theoretical discourse on photography.

One contribution, as simple as it is fundamental, consists in grasping photography as a visual expression within an intertextual structure which makes breaches in the boundaries of the photographic work and thus opens it up. Photography itself becomes a construct which despite a technically-determined completeness and despite its socio-economic and cultural determinants is subject to changes in meaning allocations, in more and more – real or imagined – new contexts. An example given by the English artist and theoretician Victor Burgin may serve to explain the term *intertextuality*: "Perhaps the most simple example I can offer here, to give a rough idea of the notion of 'intertextuality', is of the drink advertisement which shows a glass slipper containing ice-cubes and a measure of vermouth; consciously or not, I am referred instantaneously to: 'Cinderella' (rags to riches; romantic love); 'drinking from a slipper' (*fin-de-siècle* playboys and chorus-girls; physical sexuality); 'Americanness' ('on the rocks' – for example, scenes in B-movies of drinking in piano-bars); 'failure' (for example, an unsuccessful marriage is conventionally referred to as 'on the rocks'); and so on. All of this, and more, belongs to the fields of what Barthes

calls the '*déjà-lu*': the 'already read', 'already seen', everything we already know and which the text may therefore call upon, or 'accidentally' evoke."

The plurality of meaning does not just hinder an exhaustive reading of the work, it also facilitates the critical dissolution of fixed schemes of meaning. As soon as the work itself (or its creator) as the sovereign of meaning is deprived of power, like a ruler over his people, the interpretation of the work takes place in the social arena and a multitude of heterogeneous discourses is assigned to the structure of the photographic image. Today the socio-economic, cultural and, in addition, the academic integrations and definitions of photography as separate genres of scientific photography . . . illustrative or documentary photography, private photography, commercial atelier photography, art photography or experimental photography . . . are no longer tenable (and just how resourceful has the connoisseur to be today to establish erotic or pornographic photography as further categories). The lines of demarcation between the different genres of photography are blurred in both the commercial and the artistic realms (and here too a distinction can only be made arbitrarily), or else they are being entrusted to their professional seconds – curators of museums, art critics, computer scientists, and advertising strategists.

"The theory of photography", wrote Wolfgang Kemp in anticipation of developments after 1980, could be justified in "disbanding itself in favour of a theory of experience." In fact in the 70s Roland Barthes had already begun to "complement" his semiotic readings of photography by means of phenomenologically-based readings, whereby logically, the latter were no longer in harmony with the former. In *Camera Lucida: Reflections on Photography* Roland Barthes had distinguished two levels of meaning in considering photography. In the *studium* we confront the photograph with an interest schooled by an ethical and political culture, and with a viewpoint more or less strongly bound to a culture and a context we attempt to reach an interpretation which might correspond approximately to the intention of the photograph (or the task of the photographer). Thus our experience would have to be satisfied with making an exhaustive assessment of the message of the photograph and stopping, suspending or arresting any further potential it had as regards meaning. (Burgin correctly referred to the fact that in the *studium* meaning is "arrested in the name of an experienced certainty".) It is above all knowledge, i.e. the mastery of the ideological and cultural code, which qualifies us for the *studium* of a photograph. For the *punctum*, the vectors of the gaze, of its alignment and its intention, are shifted. Barthes chose this term,

this name, in order to denote the wound which a photograph and/or a detail in a photograph can leave behind in the viewer. In the *punctum* something emerges from the image and punctures, riddles the discourse of mastery, or, as Derrida remarks, "a point of singularity riddles the surface of the reproduction – and even of the production – of analogies, similarities and codes." What affects us in the *punctum* is the "absolute singularity of the other", which is only approachable in its disappearance. The referent was there, but withdraws forever from its and my presence, constantly returning.

The large-format tableaux by Marc Viaplana and Mabel Palacín, dating from 1992/1993, have a title which in all its variations and in never-ending approaches scans the works themselves as well as the photographic. The *Suite de las desapariciónes* suggests a series of disappearing appearances in tableaux which are made up of groups of photographs arranged 6x4 or 5x4. The rest of the title is in parenthesis: *(What has never been cannot end)*, and each picture, as a musical variation of a "movimiento", is integrated into a contrapuntal composition constituted by the repeatedly postponed strains of expiration. Projectiles which already have their trajectories behind them and have been deformed in different ways by the target, are held up between thumb and index finger in front of the camera as if exhibited before a witness or a court. The bullets have struck, have perhaps pierced a surface and are now present as mere circumstantial evidence. What was – the reason, the intention, the taking aim, the shot, the wound, the death – reaches us as a projectile, with its outermost end, that unvarying point which first touched the other – and may have even destroyed it. Also belonging to this series of "movimientos" is a series of portraits, people whose faces, as if covered by moiré, appear dotted, unreal like Boltanski's gravestones of history, but real in their complete isolation. *Nothing* has disappeared. The works of Viaplana and Palacín – and in a broader context this also applies to Thomas Florschuetz' bodymarks (*Plexus*) – make the question of the referent more dense. These photographs are marked not by disappearance but by contorted presence, postponed death – *(What has never been cannot end)*. The American art critic Craig Owens saw in the expounding of the problem of the referent the new contribution made by post-modern photography. In his reading of Barthes' last book, Derrida underlines the importance of the referent and/or reference:

"It is the modern possibility of photography (whether art or technology is unimportant here) which joins together death and the referent in one system. This is not the first time this has happened, and this connection, which is linked in an essential way

with reproduction technology, with technology per se, has not waited for *photography*. But the immediate evidence for it provided by the photographic apparatus, or the structure of the *remainder* which it leaves behind, are irreducible, indisputable, original elements. This signifies the failure, or at least the limits of all that which in language, literature, and in the other arts seemed to ground those simplistic theorems about a general devaluation of the *referent* or of that which is subsumed under this broad and vague term in sometimes caricatural simplification. At least at that moment when the *punctum* tears space, the reference and death join forces with photography."

Let us not delude ourselves, let us not be led astray by the ghosts, for it is not the reference to the real which disappears, rather the apparatus of photography has challenged us to consider the paradoxes in the *testimony* to the real. The bizarre aspect of the medium of photography, its *hallucinatory effect* (Barthes) lies in the fact that it is false at the level of perception but true at the level of time. Thus photography does not fall victim to arbitrariness, as many believe, but is open and connected with work on the referent, be the latter in the realm of art history, politics or culture. Our task is to translate the photographic representation into our time: we have to find an equivalent in our critique for the terror which originates in what has been. But the referent is devalued when it is entrusted to a tradition as a mere stylistic means, only serving as a reference in a museum index. In museums, incisions into time are laid out and hemmed in by borders of empty phrases, like Martin Parr's light switch by floral kitsch. Such a patchwork was to be seen in the exhibition *Photography Until Now*. In 1989, the jubilee year of photography, John Szarkowski took leave of his long-term activities as curator of the Museum of Modern Art (from 1962) with a walk through the picture gallery of photography, from Talbot to Nicholas Nixon. Szarkowski ends his wide-ranging commentary on the history of photography with a look to the future: "Photographs are made not essentially by hand but by eye, with a machine that records with unforgiving candor the quality of mind informed by that eye. Second thoughts that veil that candor do not often make the picture better. [. . .] To avoid unnecessary misunderstandings, especially their own, most photographers of ambition and high talent would prefer today to serve no instrumental functions – no 'useful' goals. They wish simply to make pictures that will – if good enough – confirm their intuition of some part or aspect of quotidian life." A comparison of the very different discourses would be presumptuous, and it would be just as unproductive to want to oppose this historically expert and extremely elitist viewpoint to one which is motivated by ideology criticism and

discourse analysis. The photographic machine, according to Szarkowski, would only be a mediator between eye and mind, strict in its truthfulness, and subordinate to the genuine creativity of the artist. Soon, Talbot wrote 150 years ago, it will be possible to differentiate in photography, as in painting, between a Rembrandt and a Raffael.

Within the visual arts photography has now taken up this position. No longer does the singularity of photography lie in time but in the signature. Thus it has found a discourse which distorts gazes *at it* and *in it*, should these only be reflected on in terms of style, that is, placed under surveillance. It is a cause for some concern, therefore, that Szarkowski included Cindy Sherman in his show (and his museum) alongside Rauschenberg and Warhol. Her style, according to Szarkowski's *studium*, lies in staging herself. . . Let us close the mighty portal of the mausoleum and remain on the way to photography.

Hubertus von Amelunxen

N.B. In the last third of the 19th century a spiritualist photographer replied to the judge's question as to whether he was a medium or not: "No, I am only the photographer."

Angela Bergling

Manchmal muß man zur Mündung des Flusses fahren, um die Quellen zu finden. Die sinnlichen Töne eines Saxophons weisen den Weg nach New Orleans, *back to the roots*. Es sind die unwiderstehlichen Klänge der Blasinstrumente, die den (Lebens-) Rhythmus der Musiker auch nördlich der Rampart Street bestimmen. Ebenso geht es den Vätern des Funk, die sich immer wieder auf den Weg zu ihren Ursprüngen machen. Wie Maceo Parker, der mit der Rebirth Brass Band musikalisch nach Hause marschiert. Mit Philip Frazier, Keith Frazier, Ajay Mallery, Kenneth Jerry, Reginald Steward und Roderick Paulin die Tradition pflegen, ohne stehenzubleiben. So halten die Musiker das Bewußtsein wach für eine kulturelle Identität, die vor allem von weißen und oft auch von schwarzen Amerikanern verdrängt wird.

Der überraschende Auftritt der Rebirth Brass Band läßt den Alltag vergessen: Neugierige Kinder unterbrechen ihr Spiel, Nachbarn kommen aus den Häusern, zufällige Passanten stoppen ihren Wagen, die angenehme Kühle des Abends nach der sengenden Hitze des Tages, das Community Book Center als Treffpunkt – Momente, die die Porträts bestimmen, auch wenn sie zunächst unsichtbar bleiben.

Der Fotoapparat fragmentiert die Zeitläufte, während die Erfahrung der Fotografin der Simultaneität verhaftet bleibt und zunächst nur bruchstückhaften Ausdruck in den einzelnen Bildern findet. Die Rekonstruktion dieser Erfahrung, in der Synthese mit den vom Apparat festgehaltenen Momenten, schafft eine eigene Dimension von Zeit-Raum.

Johannes Wachs

Sometimes one must travel to the mouth of a river in order to find the source. The sensual tones of a saxophone lead the way to New Orleans, *back to the roots*. The irresistible sounds of wind instruments also determine the (life-) rhythm of those musicians north of Rampart Street. The same applies to the fathers of funk who are forever setting out on the road to their origins. Like Maceo Parker, marching home musically with the Rebirth Brass Band. Along with Philip Frazier, Keith Frazier, Ajay Mallery, Kenneth Jerry, Reginald Steward and Roderick Paulin, all of whom preserve tradition, but without coming to a standstill. In this way the musicians keep awake their consciousness of a cultural identity which is being repressed, mainly by white but often also by black Americans.

The surprising appearance of the Rebirth Brass Band makes people forget the everyday: curious children interrupt their game, neighbours come out of their houses, chance passers-by stop their cars, the soothing coolness of the evening after the scorching heat of the day, the Community Book Center as meeting point – moments which determine the portraits, even if they remain invisible at first.

The camera fragments the time sequences whilst the experience of the photographer remains rooted in simultaneity and at first only finds partial expression in the individual images. The reconstruction of this experience, in synthesis with the moments held fast by the camera, creates its own dimension of time and space.

Johannes Wachs

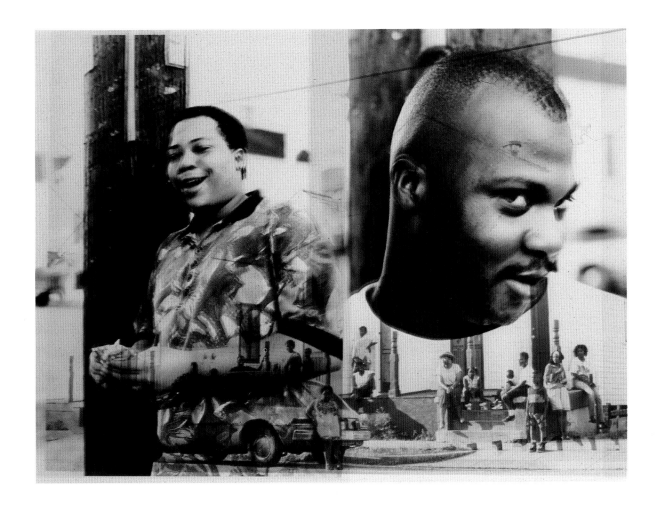

Rebirth, New Orleans, 1994. Part 1. From the Series "Maceo Parker and Friends" (24.5 x 92 cm)

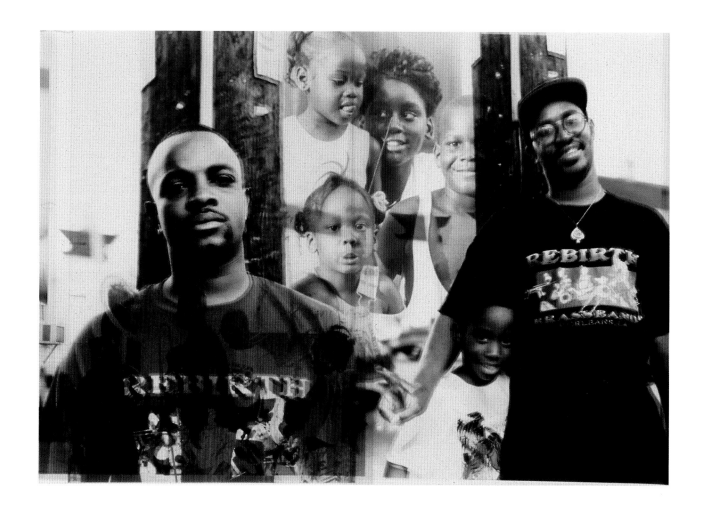

Rebirth, New Orleans, 1994. Part II. From the Series "Maceo Parker and Friends" (24.5 x 92 cm)

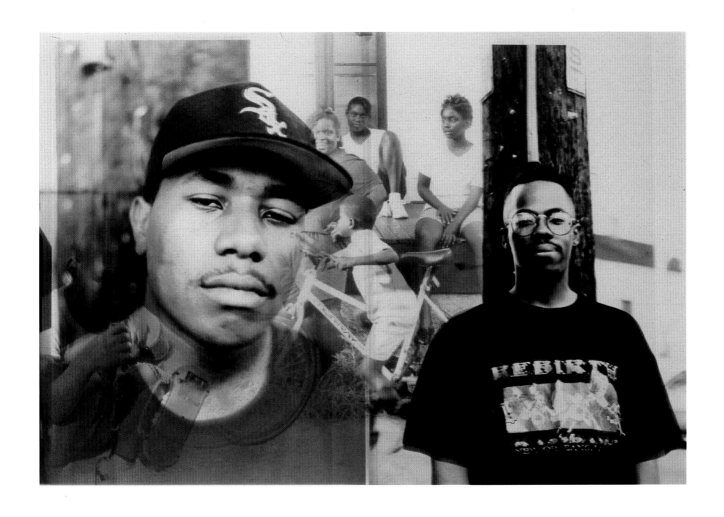

Rebirth, New Orleans, 1994. Part III. From the Series "Maceo Parker and Friends" (24.5 x 92 cm)

DIRK BRAECKMAN

DIRK BRAECKMANS FOTOGRAFIEN entstehen in erster Linie in der Dunkelkammer. Während er in seinen früheren Arbeiten den fotografierten Personen noch förmlich Gewalt antat, wenn er die Abzüge mit Entwicklerflüssigkeit malträtierte, so ist seine Ausarbeitung heute subtiler. Durch Teilsolarisation und Manipulation mit dem Entwickler wird jedes Bild zum Unikat, zu einer einmaligen Interpretation der aufgenommenen Szene.

Die Geschichte bleibt autobiografisch: Jedes Porträt ist ein Selbstporträt. Zusammen bilden sie ein Bildertagebuch der Leben, Lieben und Begegnungen von Dirk Braeckman. Er wählt seine Freunde, Kollegen, Bekannten und hält sie fest, dort, in eben jenem Moment. Sie gaben ihm, was wir sehen, und mehr oder weniger entblößten sie sich vor ihm. Was so verblüffend ist, ist die dramatische Spannung zwischen dem, was Menschen über sich offenbaren wollen und was sie tatsächlich offenbaren.

Braeckmans Bildsprache formuliert sich weiter in frontal aufgenommenen Porträts, oft fast lebensgroß mit einem klaustrophobischen Rahmen versehen und eingehüllt in einen dunklen, matten, silbergrauen Dunst. In dieser übersteigerten Wirklichkeit werden seine Modelle nicht bloßgestellt. Er scheint ihnen zu versichern, alles zeigen zu können, ohne Risiko und ohne im tiefsten Selbst angreifbar zu werden.

Dirk Braeckmans Thema ist, mehr als alles andere, seine Existenz im Sinne eines Ereignisses. Die widerstreitenden Gefühle, in denen sich intuitiv seine persönliche Realität offenbart, machen aus dem Voyeur einen Visionär. Braeckman fotografiert nicht mit bösen Hintergedanken; seine Inszenierungen erscheinen als etwas Spontanes, Uninszeniertes. „Was immer neben dem Rahmen passiert, will auch in ihn hinein." Eine Fotografie von Dirk Braeckman ist kein Spiegel; allenfalls ist sie eine flüchtige Spiegelung.

ERIK EELBODE

DIRK BRAECKMAN DEFINES HIS IMAGES in the darkroom. In the past the figures portrayed were almost violated by his technique of rubbing and brushing with developer; more recently the processing has been more subtle. Partial solarisation and manipulation by rubbing the developer creates one-off images of what took place in front of the camera.

The story remains autobiographical: every portrait is a self-portrait. Together they form a diary of images – the life, loves and encounters of Dirk Braeckman. He selects and preserves his friends, colleagues, acquaintances, as they were, there, at that very moment. They gave him exactly what we see and they, more or less, bared themselves to him. What is intriguing is the dramatic tension between what people want to reveal about themselves and what they actually reveal.

Braeckman's visual language formulates itself further in frontal portraits, often nearly life-sized with a claustrophobic frame and veiled in a dark mat silver-grey haze. Reality is enhanced and at the same time his models are not exposed. He seems to assure them that they can show everything and still remain safe. No one can touch their deepest self.

Dirk Braeckman is concerned, above all, with his existence as an event. His conflicting emotions, which gave rise to an intuitive unveiling of a strictly personal reality, transform the voyeur into a visionary. Braeckman does not make photos with malice in mind; the staging seems to occur spontaneously, without being staged. "Whatever happens near the frame also wants to be inside it." A photograph by Dirk Braeckman is not a mirror; at the most it is a momentary reflection.

ERIK EELBODE

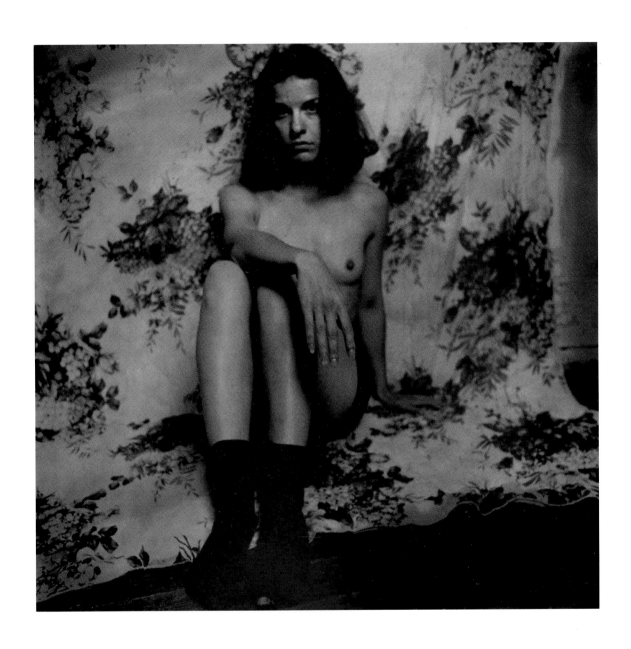

Cris, Ghent, 1992 (110 x 110 cm)

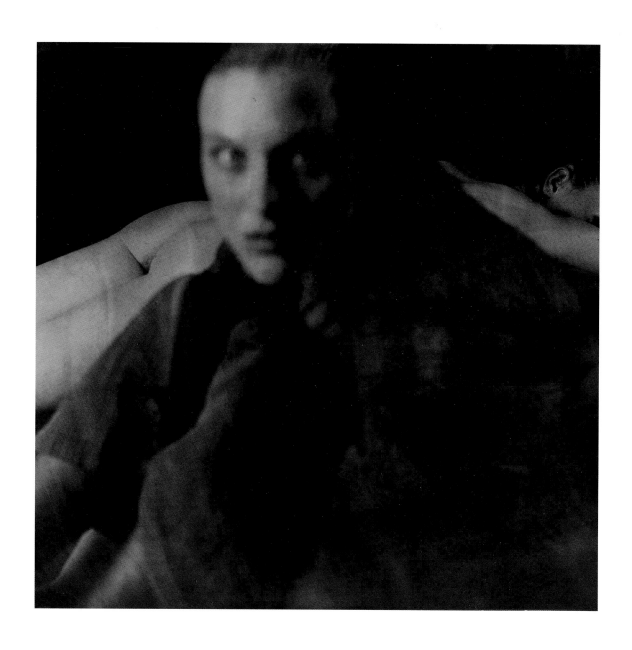

Sabisha & Fanny, Ghent, 1992 (80 x 80 cm)

28

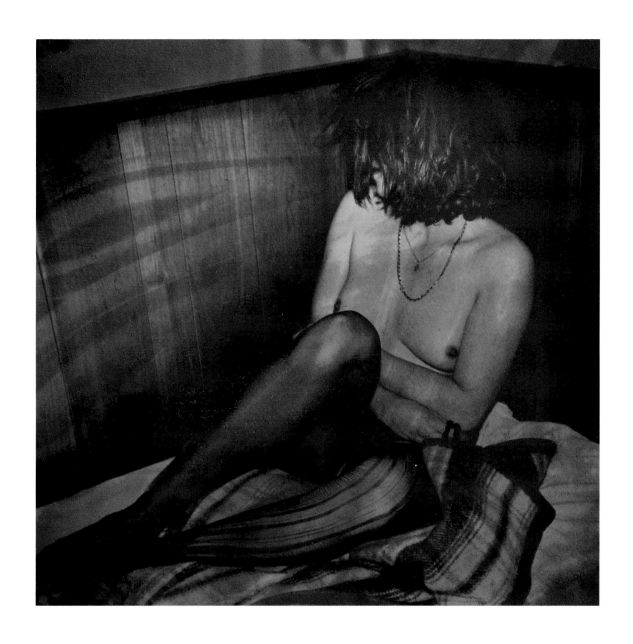

Fanny, Paris, 1993 (110 x 110 cm)

GILLES BUYLE-BODIN

IN IHRER ARBEIT *spielt das Porträt die wesentliche Rolle.*

Das Porträt bringt mich gewissermaßen zum Ursprung meiner fotografischen Arbeit zurück. Fotografieren ist eine sehr spezifische Tätigkeit. Wie die meisten von uns hatte ich in meiner Jugend lebhafte Fantasien, doch in meinem Fall bestand der feste Wille, mit diesem Material weiterzuarbeiten. Diese Fantasien hatten fast immer mit Gesichtern zu tun, und daran möchte ich mit meinen Porträts anknüpfen.

Gehört Ihre Arbeit in erster Linie in den Bereich der Empfindung? Oder in welcher fotografischen oder künstlerischen Tradition sehen Sie sich selbst?

Ich versuche, mich eher im Kontext der Darstellung zu sehen. Es gibt einen wichtigen Text, *Ontologie des fotografischen Bildes,* in dem André Bazin zu dem Schluß kommt, die historische Entwicklung der Kunst sei die beständige Suche nach einem illusionären Realismus. Perspektive, Fotografie und Kino sind für ihn Instrumente, die es uns erlauben, eine parallele Welt wiederzuerschaffen, faszinierend wie die Welt der Träume. Das ist zugleich richtig und falsch. Was mich an der Fotografie interessiert, ist diese verschobene Realität.

Wie stehen Sie zum Begriff der Identität?

Die Fotografie ist im Grunde unfähig, Identität zu erfassen. Für mich ist dies ein Spiel mit den Grenzen, denn Identitäten verändern sich ständig. Also bediene ich mich der Fotografie wegen ihrer Ambiguität, sei es aus Enttäuschung oder aus Einsicht. Man glaubt, etwas darzustellen, was unmöglich ist, und der Betrachter glaubt, etwas zu sehen, was er unmöglich sehen kann.

Sämtliche Gesichter, die Sie fotografiert haben, scheinen denselben Ausdruck der Leere zu besitzen.

Es gibt einen wichtigen Aspekt in meiner Arbeit, nämlich die Untersuchung der Pose. Das ist gar nicht so einfach, denn hier gibt es eine Menge Stereotypen. Ich versuche, jede Komplizenschaft und jede voreilige Interpretation zu vermeiden. Die Modelle schauen den Betrachter nicht an, sie schweben über der Zeit, sie sind sozial unbestimmt. Der Ausdruck der Leere, von dem Sie sprechen, ist in Wirklichkeit das Fehlen von Referenzen, das eine kontemplative Stimmung im Betrachter erzeugen soll.

INTERVIEW: THIERRY PASSERAT

THE PORTRAIT *plays a particular role in your work.*

In a way the portrait takes me back to the origins of my work. Taking photographs is a very specific activity. Like most of us, in my youth I too had vivid fantasies, but in my case I was fully determined to continue to work with that material. These fantasies almost always had to do with faces, and it is this that I want to take up again in my portraits.

Does your work have primarily to do with feeling? Or what photographic or artistic tradition do you see yourself in?

I try to imagine myself more in the context of representation. There is an important text by André Bazin, *The Ontology of the Photographic Image,* in which he comes to the conclusion that the historical development of art is constituted by the continual search for an illusory realism. For him, perspective, photography, and cinema are instruments which allow us to create a parallel world as fascinating as the world of dreams. This is right and wrong at the same time. What interests me about photography is this altered reality.

How do you feel about the term identity?

Basically, photography is incapable of recording identity. For me this is playing with borders, for identities are constantly changing. Therefore I use photography because of its ambiguity, be that as a result of disappointment or of insight. You believe you are representing something, which is impossible, and the viewer believes he sees something which he cannot possibly see.

All the faces you have photographed seem to have the same expression of emptiness.

One important aspect of my work is that it examines poses. That is not as simple as it sounds, for there are lots of stereotypes. I try to avoid all forms of complicity and rash interpretation. The models are not looking at the viewer, they are hovering above time, they are socially indeterminate. The expression of emptiness of which you speak is actually the absence of references and is intended to awaken a contemplative mood in the viewer.

INTERVIEW: THIERRY PASSERAT

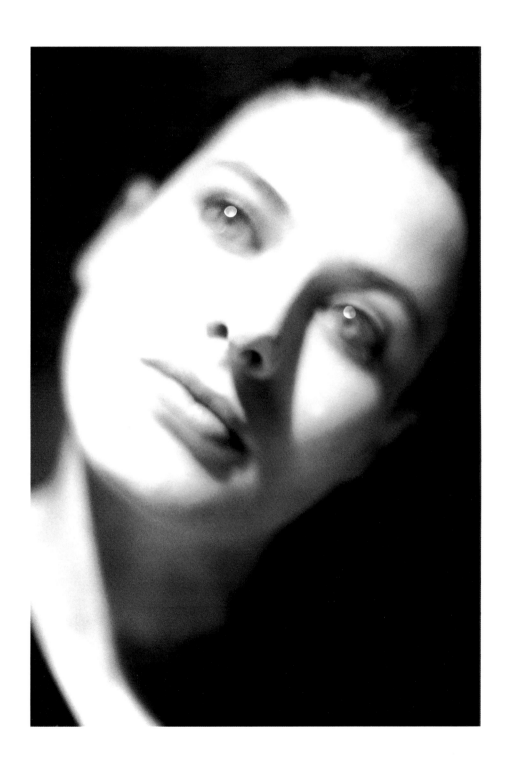

Untitled, 1992 (48 x 32 cm)

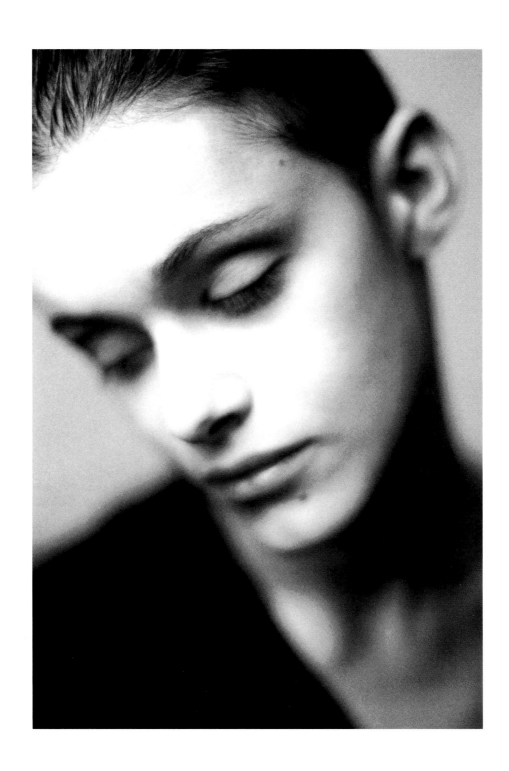

Untitled, 1987 (48 x 32 cm)

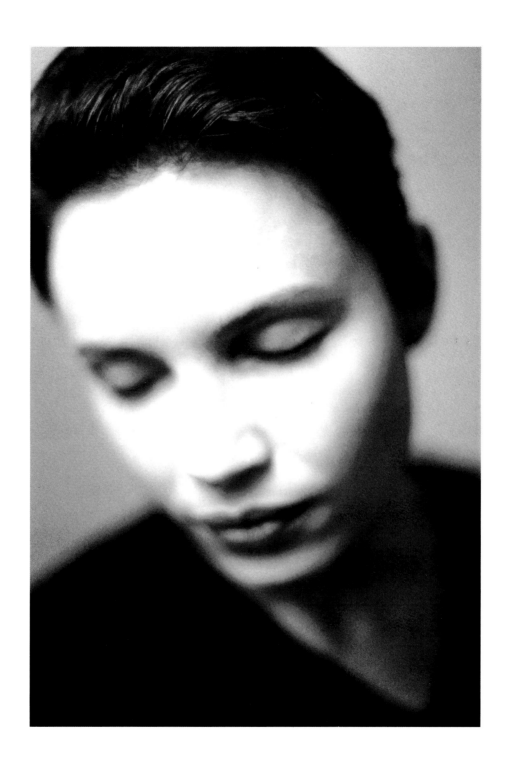

Untitled, 1987 (48 x 32 cm)

Hervé Charles

Man kann sich die Frage stellen, ob eine Wolke fotogen sei. In stetiger Veränderung begriffen, ist sie ein Zufallsgebilde, das mit kurzer Belichtungszeit festgehalten werden muß, um doch nur einen flüchtigen Augenblick preiszugeben. Bedenkt man allerdings, daß die Wolkenmasse nur dank des in die Wassertröpfchen fallenden Lichts existiert und Form gewinnt, dann ergibt sich die Verbindung zur Fotografie, zur Lichtschrift. Und die Fotografie in ihrer Nichtmaterialität ist zweifellos das ideale Medium, um diesen Körper unantastbar, unfühlbar und durchsichtig darzustellen, gleichsam abstrahiert von der Wolke selbst.

Dies um so mehr, als Hervé Charles seine Wolkenbilder auf transparenten Film vergrößert, von dem jeweils zwei Abzüge mit vier Zentimetern Abstand hintereinander und das Ganze mit einigen Zentimetern Abstand zur Wand montiert werden. Das durch die zwei Ebenen dringende und einen Schatten auf die Wand werfende Licht veranlaßt das Auge, zwischen den beiden Bildern unablässig hin und her zu wandern und erzeugt so unwillkürlich eine Tiefe, durch die die unablässige Veränderung der Wolkenwelt nachempfindbar wird. So entsteht ohne weiteren Eingriff in die Wirklichkeit, auch nicht bei der Aufnahme, eine räumliche und sinnliche Vieldeutigkeit – und zugleich ein Gefühl der Ruhe und des Friedens, so als würden wir wahrhaftig in dieser Traumwolke versinken.

Was die Form des Tondos angeht, so vertieft sie uns noch mehr in die Stille und Kälte dieser unberührten Räume als die eckige Form, die eher dazu neigt, die Abbildvorstellung in Frage zu stellen. Abgesehen davon, daß das Tondo aus der hier suggerierten ätherischen Sicht die Rundheit der Erde in Erinnerung ruft, entspricht diese weiche geometrische Form letzten Endes ganz besonders dem, was man als Wolken schlechthin bezeichnen könnte: Der Kreis ist tatsächlich, wie es der Künstler auch empfindet, das Symbol für Himmel und Weltall, "harmonisches Ganzes par excellence" (Mircea Eliade) und jenseits davon Symbol für alles Geistige und Heilige.

Anne Wauters

One may ask whether a cloud is photogenic. A cloud is a chance form in a constant process of change, for which a short exposure is necessary when photographing, and which even then only surrenders one fleeting moment. However, if you consider the fact that the cloud mass only exists and takes shape thanks to light falling onto tiny particles of water, then the connection emerges to photography, to light-writing. And in its non-materiality photography is without doubt the ideal medium for representing this mass, untouchable, impalpable and transparent, abstracted, as it were, from the cloud itself.

And this all the more so, as Hervé Charles enlarges his cloud photographs onto transparent film, of which two different copies are mounted one behind the other at a distance of four centimetres from each other and then the whole mounted a few centimetres from the wall. The light, penetrating through the two levels and throwing a shadow on the wall, causes the eye to wander constantly over and back between the two levels and thus creates a spontaneous depth by means of which the constant changing of the cloud-world becomes perceptible. Thus, without any further intervention into reality, neither here nor while taking the photographs, a spatial and sensual ambiguity is created – and at the same time a feeling of peace and quiet, almost as if we were really sinking into this dream cloud.

As regards the tondo form, it immerses us even more into the quiet and the cold of these untouched spaces than an angular form which tends more to question the idea of likeness. Quite apart from the fact that the tondo, from the ethereal view suggested here, calls to mind the roundness of the earth, this soft geometric form corresponds after all particularly well to that which might possibly be designated the very essence of cloud: The circle, as the artist clearly feels, is actually the symbol of heaven and space, "the harmonious whole par excellence" (Mircea Eliade), and beyond that, the symbol of all that is spiritual and holy.

Anne Wauters

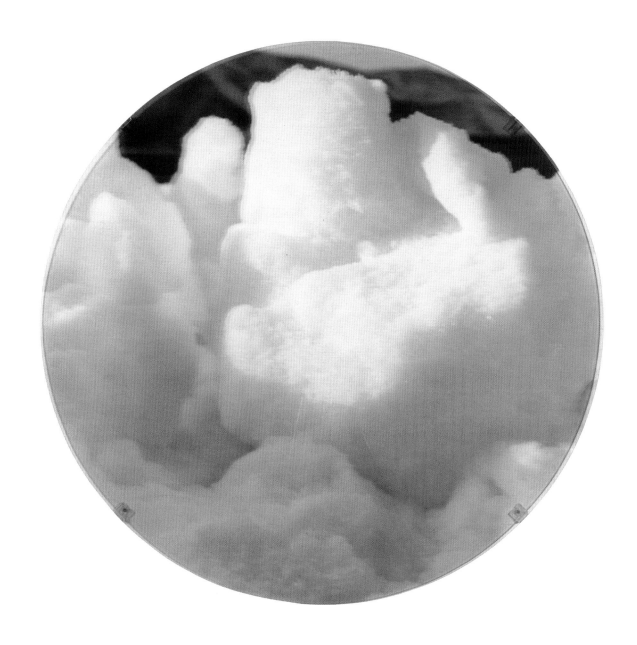

Clouds Circle 5, 1994 (100 cm)

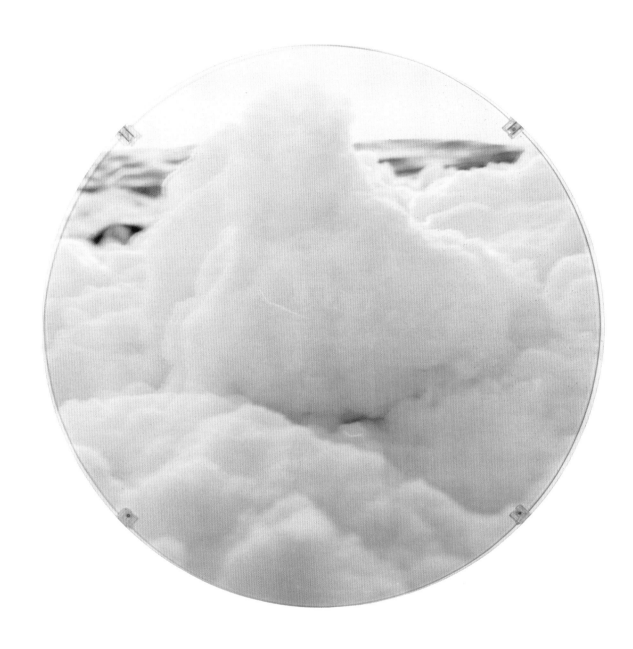

Clouds Circle 4, 1994 (100 cm)

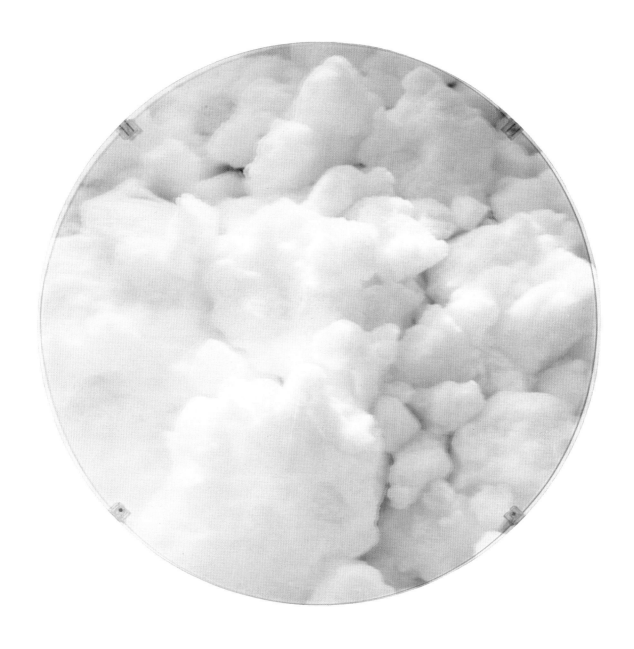

Clouds Circle 3, 1994 (100 cm)

HANNAH COLLINS

HANNAH COLLINS zählt zu jenen Künstlern, die – seit den 60er Jahren – die Fotografie zu ihrem maßgeblichen Medium gemacht haben. Ihre Arbeit ist, wie sie selbst sagt, "skulptural und bildhaft" und von oft raumgreifender Größe zwischen einem und dreißig Metern. Als Träger ihrer Fotografien verwendet sie eine Vielzahl von Materialien, darunter Leinen und Baumwollstoff, die drapiert oder in Bahnen aufgehängt werden, sowie Metallpaneele als freistehende Installationen. Der skulpturale Aspekt ihrer Arbeit ist folglich in deren räumlicher Wirkung zu sehen: "Ich beziehe den Raum ein, und zwar verschiedene Arten von Raum – den vom Werk geschaffenen Raum, den von ihm physisch eingenommenen Raum; und seine Beziehung zum jeweiligen öffentlichen oder privaten Raum, in welchem es hängt." Zugleich geht es um den häuslichen, menschlichen Raum – Zimmer, Betten, Tische, Lebensmittel, alltägliche Gegenstände. Auch die physische Beziehung zum Betrachter berücksichtigt Collins mit großer Sorgfalt. Über ein Landschaftsfoto sagte sie: "Ich schaue durch die Kamera und stelle mir die räumliche Beziehung vor, die der Betrachter zur, sagen wir, Höhe des Berges in der Wüste hat."

Hannah Collins' Arbeit umfaßt die traditionellen Kunstgattungen, wie Landschaft, Stadtlandschaft, Interieur, Stilleben, Figur, und ihre Bilder und ihre Arbeitsweise deuten unverkennbar auf Themen und Darstellungen der großen Kunst vergangener Jahrhunderte. Doch ist dieser Aspekt von untergeordneter Bedeutung angesichts der visuellen Kraft und Präsenz ihrer Werke und des Reichtums an Bedeutungen, die sich dem Betrachter offenbaren. Hannah Collins spricht grundlegende Fragen unseres Daseins an, mit nicht selten betont politischen und sozialen Bezügen, und ist zeitgenössisch im umfassenden Sinne des Wortes: "Ich bin mir bewußt, daß mein Leben von sozialen und politischen Gegebenheiten geprägt ist und sich dies in den Inhalten meiner Bilder widerspiegelt." In ihrer Kunst, sagt Collins, untersuche sie die Schnittstelle zwischen persönlicher Lebensgeschichte und dem sie umgebenden kulturellen Milieu. "Mein wichtigstes Anliegen ist, eine tiefe Verbindung herzustellen zwischen meiner Arbeit und dem Umfeld, in dem sie entsteht."

SIMON WILSON

Überarbeitete und gekürzte Fassung des Katalogtexts zum *Turner Prize 1993*.

HANNAH COLLINS is one of a growing number of artists who, since the 1960s, have adopted photography as a central medium within their work. Collins has remarked that her work is "both sculptural and pictorial". It is often installational, varying in size from one to thirty metres. The photographic images are mounted onto a variety of supports, including linen or cotton draped or hung like banners, and metal panels arranged as free-standing installations. The sculptural aspect of her work thus lies in its environmental and spatial qualities: "I take space into account and there are different kinds of space at work – the space created by the piece, the space it occupies physically; how it relates to the public or private space in which it hangs." At the same time it is about contemporary domestic, human space – rooms, beds, tables, food, objects of everyday use. Collins also considers the physical relationship to the spectator with great care. Discussing a landscape work, Collins said, "I look in the back of the camera and work out the relation between the viewer and, say, the height of the mountain in the desert."

Pictorially, Collins's work embraces the categories of traditional art: landscape and cityscape, interiors, still life, the figure. In her images and in her treatment of them there are frequent echoes of the themes and imagery of the great art of the past. But these references are always secondary to the sheer visual power and immediacy of Collins's works, and to the meanings they evoke. Hannah Collins touches on many fundamental human issues and her art often has political and social resonances. It is strongly related to its own time and to her personal response to it: "I am aware that social and political truths are embedded in my life and that these are reflected in the content of my work." She has said that in her art she explores the interface between personal history and the specifics of the culture in which she finds herself. "The most important thing for me is that my work develops deep links with the environment in which it is made."

SIMON WILSON

Edited version of a text published in the *Turner Prize 1993* catalogue.

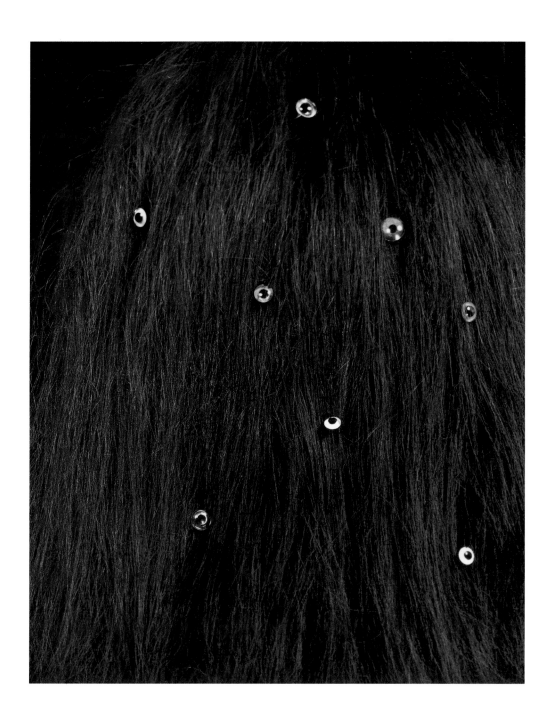

Hair with Eyes, 1992 (160 x 118 cm)

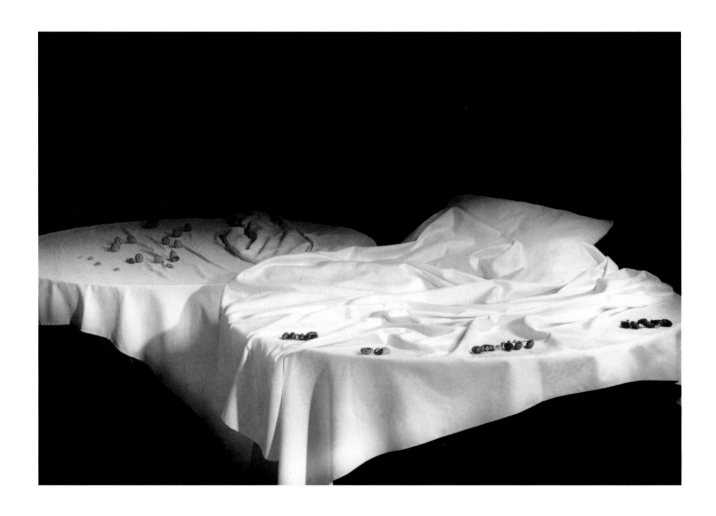

Revolving, 1992 (205 x 286 cm)

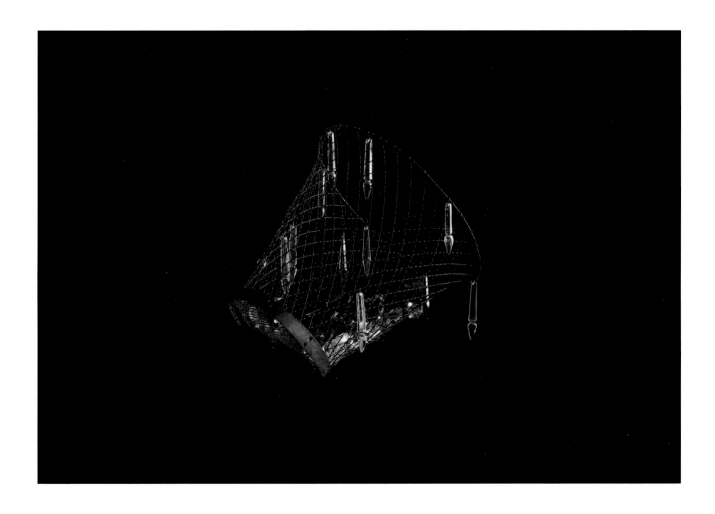

Untitled (Basket with Glass), 1991 (141 x 186 cm)

41

Marina Cox

Sie heissen Reuf, Nisveta, Vahidin, Fahira, Almir, Mirza oder Jasmin. Sie sind Bosnier, doch sie leben in Slowenien, in Flüchtlingslagern, in die sie die Erschütterungen der Geschichte im Herzen Europas geführt haben. Sie gehören zu jener täglich größer werdenden Familie von Personen, die millionenfach durch Kriege und Hungersnöte, durch den Wahnsinn der Menschen oder die Launen der Natur vertrieben wurden. Diese Flüchtlinge stammen aus einem Gebiet, das uns seit einigen Jahren von neuem an Namen erinnert, die in Vergessenheit geraten waren und die uns heute, allein bei der Erwähnung des Ortes Sarajevo, wie ein Resümee der europäischen Geschichte erscheinen, vom Tag der Ermordung eines Erzherzogs bis zum Martyrium einer Stadt. Da sind Männer, Frauen, Kinder. Opfer – und unser schlechtes Gewissen. Fragen ohne Ende, ohnmächtige Fragen. Was soll man tun? Was sagen? Was zeigen?

Vielleicht einfach nur die Individuen oder Familien so darstellen, wie es der quadratische Sucherausschnitt gewährt. Ihnen direkt ins Gesicht schauen, ihren Blick suchen, erbitten. Frontal, in einer Sicht, die, wenn sie schon nichts zu ändern vermag, doch wenigstens bezeugt, daß wir uns nicht des Verbrechens des Wegschauens schuldig gemacht haben.

Die Flüchtlinge in den Lagern Sloweniens stellen sich dem Objektiv, um ihre Existenz zu bekunden. Die Fotografin nimmt dies auf wie eine Spur, registriert das Unannehmbare, schweigt, hört zu, zieht sich zurück, läßt das Licht sprechen. Zwischen Innen und Außen, dem Rhythmus des sich vergrößernden Bildausschnitts folgend, erscheinen Zeichen, diskret, winzig und prägnant vor dem Hintergrund trocknender Wäsche, vor Gittern und Mauern. Innerhalb dieses Raumes, von dem man wünschte, er wäre nur ein vorübergehender: Blicke, doch niemals anklagende Blicke, sondern Blicke, die auf uns zutreiben mit der ganzen Schwere schweigender Fragen. Wir vermögen nichts anderes als zuzuschauen und Zeugnis zu geben. So bleibt uns nur die Hoffnung.

Christian Caujolle

Their names are Reuf, Nisveta, Vahidin, Fahira, Almir, Mirza or Jasmin. They are Bosnians, yet they live in Slovenia, in refugee camps into which they have been forced by the turmoil of history at the heart of Europe. They belong to that continually growing family of people who have been driven out of their homeland by the millions due to wars and famine, because of human madness, or by the vagaries of nature. These refugees come from a region which over the past few years has been calling to our minds again names which had been long forgotten and which today, at their mere mention, seem like a summary of European history, from the day of the murder of the archduke to the martyrdom of the city of Sarajevo. There they are, men, women, children. Victims. Our bad conscience. Endless questions, helpless questions. What should we do, say, show?

Perhaps just present the individuals or families as the square view-finder allows. Look them straight in the face, ask them to look our way, catch their eye. Head on, a view which even though it cannot change anything at least bears witness to the fact that we have not been guilty of the crime of looking away.

The refugees in the camps in Slovenia face the lens so as to testify to their existence. The photographer takes this up, like a trail, registering the unacceptable, staying silent, listening, withdrawing herself and letting the light speak. Between inside and outside, in keeping with the rhythm of the gradually expanding view, signs appear, discreet, tiny and succinct against a background of washing out to dry, fences and walls. And inside this space, which one would like to feel was only temporary, those looks, never accusing, but which surge towards us with the full weight of silent questions. We can do nothing more than return their gaze and bear witness. Hope, therefore, is all we have left.

Christian Caujolle

Jasmin Delalic. Vic II, Bosnian Refugees Camp, Ljubljana, 1993. From the Series "Izbjeglica" (60 x 60 cm)

Adam Mrkonja. Vic II, Bosnian Refugees Camp, Ljubljana, 1993. From the Series "Izbjeglica" (60 x 60 cm)

Sevleta Zukic. Postojna, Bosnian Refugees Camp, Ljubljana, 1993. From the Series "Izbjeglica" (60 x 60 cm)

Lenni van Dinther

"Um die Entwicklung des scharfen Instruments, das unser Verstand ist, zu gewährleisten, mußten andere Eigenschaften unbeachtet bleiben. So sehr, daß ich denke, daß wir nun unter den furchtbaren Konsequenzen der Vernachlässigung dieser anderen Werte leiden. Ich spreche hier von Gefühl, Intuition und Weisheit" (Meret Oppenheim am 16. Januar 1975 in ihrer Rede anläßlich der Verleihung des Kunstpreises der Stadt Basel).

Les Larmes de la Reine ("Die Tränen der Königin") sind der Versuch, den Schmerz auszudrücken, der uns angesichts der Gewaltsamkeit des Lebens überfällt. Sie rufen die Erinnerung wach an einen verschwommenen und weit zurückliegenden Traum, an eine unfaßbare Welt, gleichsam das Schweigen vor dem Unsichtbaren.

Lenni van Dinther

"To permit the development of the sharp instrument of the intellect, other traits had to be ignored. So much so, that I think we are now suffering the dire consequences of having neglected these other qualities. I am talking about feelings, intuition, wisdom." (Meret Oppenheim, January 16, 1975, in her address on the occasion of the presentation of the City of Basel Art Prize)

Les Larmes de la Reine ("The Queen's Tears") represent an attempt to express the pain which overcomes us in the face of the violence of life. They call to mind a blurred and distant dream, an unimaginable world, as it were, the silence before the invisible.

Lenni van Dinther

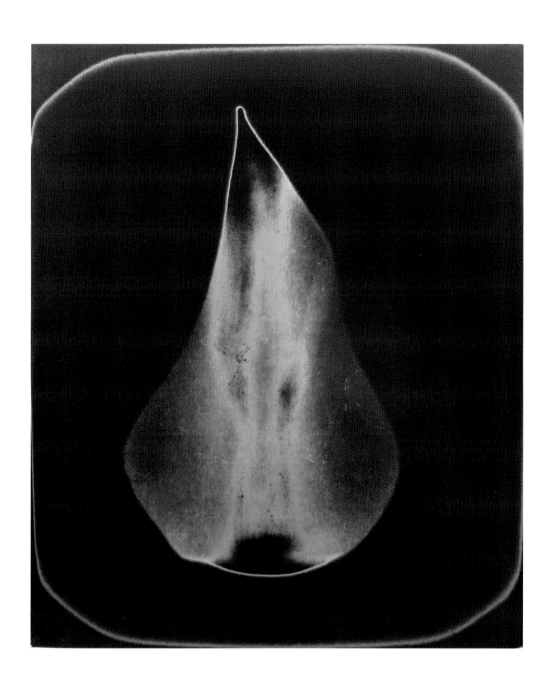

Les Larmes de la Reine, 1993–94 (60 x 50 cm)

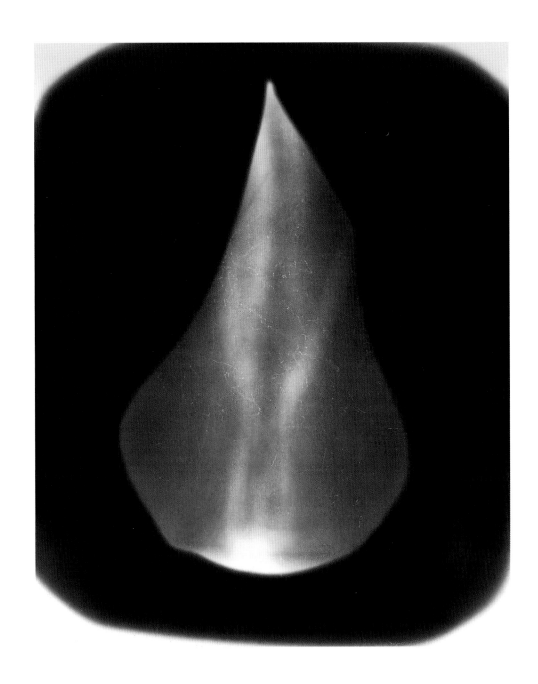

Les Larmes de la Reine, 1993–94 (60 x 50 cm)

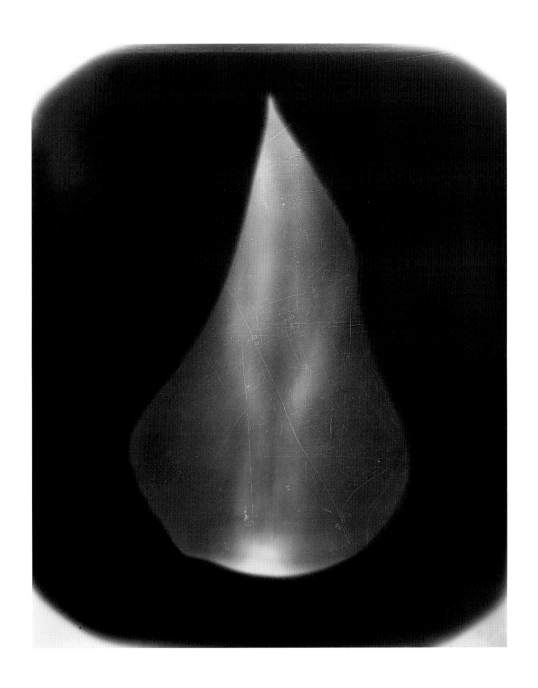

Les Larmes de la Reine, 1993–94 (60 x 50 cm)

Henrik Duncker / Yrjö Tuunanen

Die aus 29 fotografischen Tableaus bestehende Arbeit *Hay on the Highway* ("Heu auf der Landstraße") von Henrik Duncker und Yrjö Tuunanen gibt Einblicke in die gegenwärtige kulturelle Situation Finnlands. Sie entstand in Vihti und Hankasalmi, zwei von der Landwirtschaft lebenden Orten; während Vihti eine recht wohlhabende Gemeinde in nur 50 Kilometer Entfernung von der Hauptstadt Helsinki ist, liegt Hankasalmi in der ländlich geprägten Region im Zentrum des Landes. Dunckers und Tuunanens Fotografien schöpfen aus dem Alltag dieser beiden Gemeinden: Kraftvoll, amüsant, vielschichtig und mit großer Sorgfalt ausgeführt, erzählen sie von der Arbeit und vom Geschäft der Landwirte in einer Zeit wirtschaftlichen Niedergangs und einer ungewissen Zukunft im nachindustriellen Finnland.

Im Mittelpunkt der fotografischen Reflexionen steht indes nicht die Gemeinde als größere Einheit, sondern die einzelne Familie. Jedes Bild ist das Porträt einer bestimmten Bauernfamilie und ihrer gegenwärtigen Situation, ihrer Träume und Zukunftsängste, ihrer Reaktionen auf Gegenwart und Vergangenheit.

Hay on the Highway ist wesentlich vor dem Hintergrund der in den vergangenen Jahren lebhaft geführten Dokumentardebatte zu sehen. Von dieser Debatte inspiriert und durch das Studium alternativer Methoden der Dokumentation an der Helsinki School of Industrial Arts motiviert, gingen Duncker/Tuunanen daran, das klassische Thema des Landlebens auf neue Weise in Angriff zu nehmen. Während der zweijährigen Arbeit an *Hay on the Highway* entstanden eine Reihe beeindruckender Bilder und eine spezifische Methode der Bildrealisation, für die Duncker/Tuunanen die Bezeichnung "interaktive Dokumentation" bevorzugen. Damit soll gesagt werden, daß das Bild aus Gesprächen mit den porträtierten Personen erwächst, daß es das Ergebnis einer Zusammenarbeit, eines Ideen- und Erfahrungsaustauschs zwischen Fotograf und Porträtiertem ist. Doch zeugen die Bilder nicht nur von dieser interaktiven Begegnung, sie finden auch Widerhall in der Geschichte der Kunst und Fotografie – wenn etwa ein Vater während der Examensfeier seiner Tochter über die Zukunft seiner Familie sinniert und sich die Szene ausnimmt, als entstamme sie einem impressionistischen Gemälde.

Hay on the Highway bestätigt die Fähigkeit der Fotografie, dem Fragmenthaften Tiefe zu geben und Türen zum Leben anderer Menschen zu öffnen. Angesichts dieser Fotos erübrigt sich die Frage ihrer "direkten" oder "inszenierten" Entstehung; es sind lebendige Fotos einer Zeit im Wandel, Fotos, die uns anrühren.

Jan-Erik Lundström

The 29 photographic tableaux comprising *Hay on the Highway*, by Finnish photographers Henrik Duncker and Yrjö Tuunanen, visualize aspects of contemporary Finnish culture. Two villages, Vihti and Hankasalmi, serve as the focal-points of this engagement; both are agricultural communities, but while Vihti is a rather wealthy farming district only 50 kilometers from the capital Helsinki, Hankasalmi is located in the more rural region of central Finland. From everyday life in these villages, the lively, funny, multifarious and elaborate images of Duncker and Tuunanen are born, telling the story of agriculture and agribusiness in a period of economic decline and uncertain futures in post-industrial Finland.

The prism for this reflection of and on agriculture is, however, not the larger community but the individual family. Each tableau is a portrait of sorts of one farming family, a visual representation of one family's situation, their dreams or fears of what's to come, their takes on the present and the past.

An important background to *Hay on the Highway* is the lively debate on and the reassessment of documentary work in recent years. Inspired by this, and supported by the study of alternative documentary methods at the Helsinki School of Industrial Arts, Duncker/Tuunanen ventured out to discover new ways of addressing this photographically classical theme of countryside culture and farming life. After a two year project, *Hay on the Highway* had evolved – a set of striking images and a specific method of making photographs. Interactive documentary is the name Duncker/Tuunanen prefer for their method, relating the way the photographers allow each photograph to grow out of conversations with the persons to be portrayed. The final image is thus a collaboration, the result of a give and take of ideas and experiences between photographer and subject. Yet these images do not only record this interactive encounter, they also find resonance within the general histories of art and photography – such as a father contemplating his family's future at his daughter's graduation party, all of it seen as through the lens of an impressionist painting.

Hay on the Highway verifies the photograph's ability to give depth to its temporal fragment and open up doors to other people's lives. These photographs leave behind the question whether they are "straight" or "staged"; they are living, engaging images of a changing present.

Jan-Erik Lundström

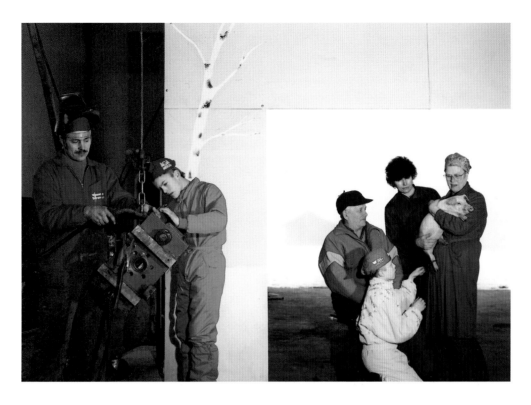

Hay on the Highway, 1993 (44 x 60 cm)

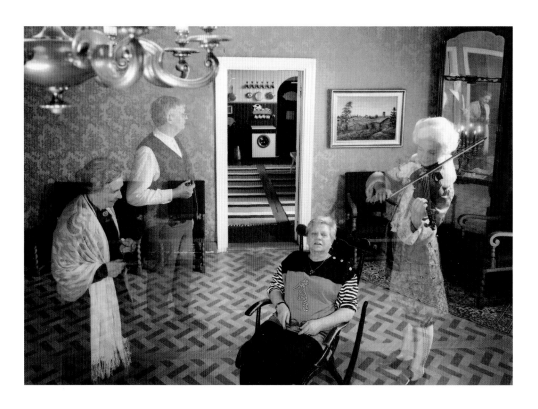

Hay on the Highway, 1993 (44 x 60 cm)

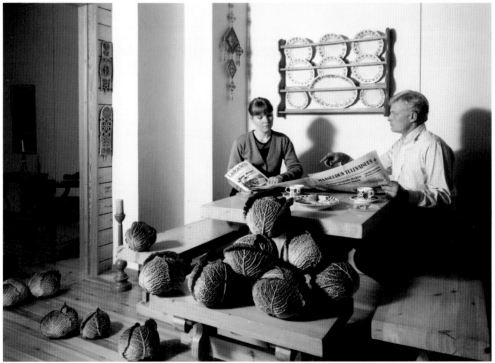

Hay on the Highway, 1993 (44 x 60 cm)

Dörte Eissfeldt

PAPIER IST GEDULDIG, Film ist geduldig – die Fotografie setzt sich zur Wehr: Sie will nicht länger sich verausgaben und verschwenden an die Motive und an die grenzenlose Unterhaltung; sie hat einen Körper, und sie zeigt ihn; sie bildet sich selbst auf allen Bildern ab, hinterläßt einen Eindruck – mal versteckt, doch zunehmend offensiv.

Sie hat einen Körper von extremer Sensibilität gegenüber Licht und Chemie, Feuer und Wasser. Sie belebt alte Kulte, Rituale von Bildgewinnung und Bilderdeutung, Aufnahme und Opfer.

Sie metallisiert den Moment, mineralisiert das Licht. Sie stoppt die hysterische Beschleunigung der Bildproduktion, die sie selbst betrieben hat, und geht über zu langen, langsamen Bildprozessen: Die Fotografie ist eine Kunst der drei Kammern und drei Körper, ein prinzipiell mehrstufiger Prozeß. Sie lädt die Bilder auf, verdichtet sie; sie schert sich nicht um Gestaltung, die führte nur dazu, Hohlheit und Leere zugleich zu produzieren und zu verbergen.

Die Fotografie schafft Modelle, Möglichkeitsformen der Verarbeitung und Bewältigung von Welt. Sie will Neugier und Altgier, die Sensation des Banalen.

Die Fotografie berührt das Universum.

Die Fotografie materialisiert das Denken.

Fotos sind wie Wale, die ganze Inseln tragen können.

DÖRTE EISSFELDT

PAPER WON'T BLUSH, film won't blush – but photography reacts: it no longer wants to exhaust itself, squander itself on motifs and endless entertainment; photography has a body and shows it; it depicts itself in all the photographs, leaving behind an impression – sometimes hidden, but increasingly on the offensive.

Photography has a body which is extremely sensitive to light, chemicals, fire and water. It revives old cults, rituals to do with capturing and interpreting images, with admission and sacrifice.

It metallises the moment, mineralises the light. It stops the hysterical acceleration of pictorial production which it had once indulged in, and moves to long slow pictorial processes: photography is an art involving three chambers and three bodies, in principle a multi-stage process. It charges the images, compresses them; it is not concerned with artistic arrangement which used only lead to the production and simultaneous concealment of hollowness and emptiness.

Photography creates models, possible forms for processing and mastering the world. It craves for the old and the new, the sensation of the banal.

Photography touches the universe.

Photography materialises thought.

Photographs are whales which can carry whole islands.

DÖRTE EISSFELDT

Bluot, 1994 (50 x 60 cm)

Bluot, 1994 (50 x 60 cm)

Bluot, 1994 (50 x 60 cm)

Touhami Ennadre

Touhami Ennadre wurde jung mit Schmerz, Leid und Armut konfrontiert. In Marokko geboren, siedelte seine Familie nach Frankreich über, als er sechs Jahre alt war und in einer Vorstadt von Paris mit der feindlichen Realität in Berührung kam. "Die meisten meiner Kameraden wurden Dealer, ich hatte vielleicht das Glück, die Fotografie als Alternative zu haben." Ennadre spricht zögernd und sichtlich unwillig über sein Leben und seine Bilder. Es sind Bilder, die schockieren: Bilder vom Schlachthof, von blutbedeckten Neugeborenen, von Pompeji, von Auschwitz.

Dabei hatte alles ganz harmlos angefangen, als Touhami in Asien und Afrika seine jetzt berühmten Hände fotografierte. Sie sind schwielig, abgearbeitet, verbraucht und strahlen doch oder gerade deshalb eine eigentümliche Würde und Schönheit aus. Aber Lichtjahre liegen zwischen diesen Werken aus den frühen 80er Jahren und den Fotos von heute. Touhami ist auf der Spur seines persönlichen Leidens und dem Leiden der Menschheit. Seine Farbe ist Schwarz, ein Schwarz der Nacht, ein ins Unendliche gehendes Schwarz. Ennadre ist ein Dramatiker des Unglücks, doch nicht festhalten will er den Tod, sondern diesen selber töten: Seine Föten, seine Skelette, seine faltigen Hände oder Eingeweide bedeuten die Ewigkeit des Lebens. Deshalb verlangen diese Bilder mehr als ein flüchtiges Hinschauen.

Helga Dupuis

In his youth Touhami Ennadre was confronted with pain, suffering and poverty. Born in Morocco, his family moved to France when he was six years old. In a suburb of Paris he came in contact with hostile reality. "Most of my friends became dealers, perhaps I was lucky to have photography as an alternative." Ennadre speaks reticently, and obviously unwillingly, about his life and his work. His photographs shock: pictures of slaughterhouses, of blood-covered newly born babies, of Pompeii, of Auschwitz.

It all began quite harmlessly, when Touhami was in Asia and Africa and photographed his now famous hands. Hands full of calluses, hard-worked, worn-out hands, yet still, or perhaps for that very reason, radiating an unusual dignity and beauty. But there are light years between those works, which date from the early 80s, and his current photographs. Touhami is on the trail of his personal suffering and the suffering of mankind. His colour is black, the black of night, a black reaching to eternity. Ennadre is a dramatist of misfortune. Yet he does not wish to capture death but rather to kill it: his foetuses, his skeletons, his wrinkled hands or winding entrails signify the eternity of life. These photographs, therefore, demand more than just a fleeting glance.

Helga Dupuis

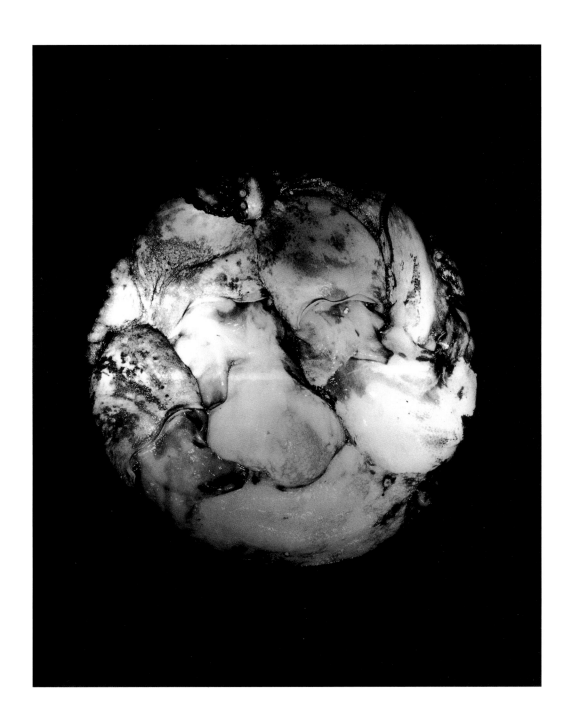

Les Poulpes, 1992 (160 x 130 cm)

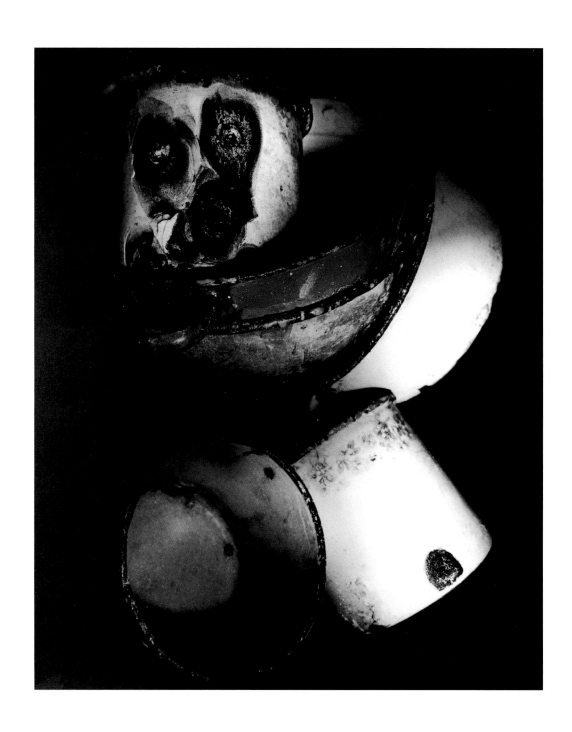

Auschwitz, 1992 (160 x 130 cm)

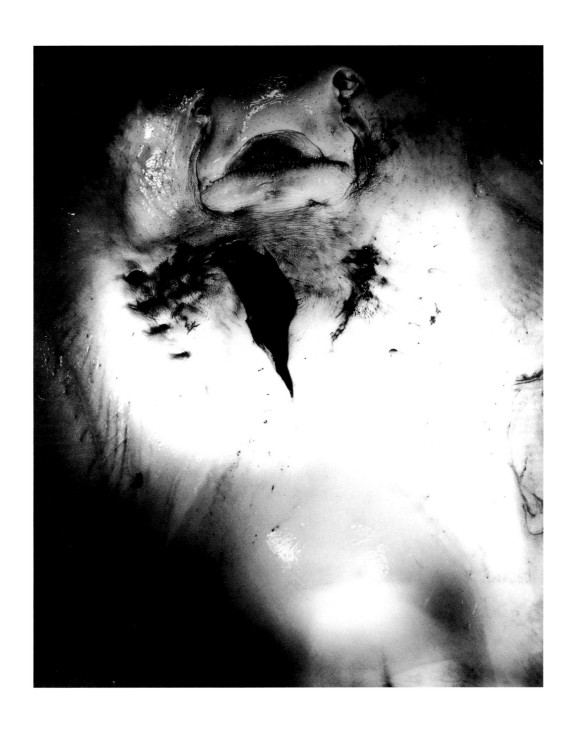

Peche et Poulpes, 1992 (160 x 130 cm)

Thomas Florschuetz

In einer Zeit, da Bild und Haut deckungsgleich werden (Illustrierte sind Hautoberflächen), die Körper illusionistisch von Wortwellen und Bildschaum umspült wie besetzte Landschaft, arbeitet der Fotograf Thomas Florschuetz beharrlich an ihrer Differenz, die sein Versteck ist, mimetische Falle, Folie für das Verschwinden der Biografie, Leinwand des Ablebens und der diskreten Revolte gegen die reißende Zeit. Wie wenige macht er die Schattenlosigkeit von fotografischem Druck und Epidermismus sichtbar, ein Konstruktivist physischer Grenzflächen, dem Form grausamer als Vertrauen ist und Dimension wunderbarer als Form.

Durs Grünbein

At a time when picture and skin are almost congruent (illustrated magazines are skin surfaces), when bodies, like occupied landscapes, are washed illusionistically by verbal waves and pictorial foam, the photographer Thomas Florschuetz is persistently preoccupied with their difference – which is his hiding-place, mimetic trap, foil for the disappearance of biography, screen of demise and discrete revolts against rapacious time. Like few others, Florschuetz makes the shadowlessness of photographic print and epidermism visible, a constructivist of physical contact surfaces, for whom form is more cruel than trust and dimension more wonderful than form.

Durs Grünbein

Untitled (Plexus), 1994 (181.5 x 121.5 cm)

Diptych #132, 1993–94 (106.5 x 143 cm)

Diptych #116, 1993–94 (181.5 x 243 cm)

ANNA FOX

PAINTBALL ist auf dem besten Wege, einer der beliebtesten Zeitvertreibe in Großbritannien zu werden: An die 200 Kriegsspiele finden an jedem Wochenende auf abgeschirmten Wald-geländen und in Gebäuden statt. Allmonatlich treffen sich die Teilnehmer zu Turnieren, einmal jährlich zu einer Europameisterschaft.

Ziel des Spiels ist es, die Fahne zu erbeuten. Dabei versuchen zwei Kampfteams, so viele Gegner wie möglich niederzustrecken. Geschossen wird mit Plastikkugeln, die eine orange Farbe enthalten. Spritzt diese beim – schmerzhaften – Aufprall heraus, ist man tot. Die Teilnehmer, häufig Verkaufsteams oder Manager, bekommen es kampfnah mit der Wirklichkeit zu tun: "Echte Tunnel und Schützengräben aus dem Zweiten Weltkrieg; Schießerei im Vietcong-Dorf; Brückensprengung à la River Kwai" – so und ähnlich lauten die Angebote der Veranstalter.

Paintball ist ein Import aus den USA, und obwohl es in Großbritannien wie eine Bombe eingeschlagen hat (besonders im Süden und um den Motorway M 25), faßt es im übrigen Europa nur langsam Fuß und ist in einigen Gegenden sogar verboten. Paintball-Veranstalter sind eifrig bemüht, Parallelen zwischen ihrem Spiel/Sport und tatsächlichen Kriegshandlungen zu vermeiden. Einer der Verantwortlichen erklärte mir: "Wenn Sie so im richtigen Krieg spielen würden, wäre es schon nach ein paar Sekunden aus mit Ihnen . . . außer natürlich in Beirut; denen könnten vermutlich selbst wir noch was beibringen." Die Gebühren liegen zwischen 120 und 250 Mark pro Person und Tag, die Teilnehmer sind überwiegend weiß und männlichen Geschlechts.

In der hier gezeigten Serie *Friendly Fire* ("Eigenbeschuß") geht es mir nicht darum, die Personen als bizarre Comic-Figuren zu zeigen, sondern im Gegenteil das Gewöhnliche meines Themas herauszuarbeiten. Ich handle wie im wirklichen Krieg: fotografiere die Aktion, die Anspannung, den Tod; doch dieser Krieg ist eine Fiktion, und ich bin eine Täuschung. Die Bilder vom Schlachtfeld ähneln "echten" Kriegsbildern, außer daß sie auf überdimensionale Größe gebracht sind. Sie werden unterbrochen von Fotografien der Toten, die durch ihr winziges Format wie Kleinode wirken. Kurz und unbehaglich zeigt der Krieg seine mythologischen Züge.

Mein Interesse gilt gewöhnlichen Leuten an gewöhnlichen Orten. Ich suche, was entsteht, nicht was vergeht.

ANNA FOX

PAINTBALL is fast becoming one of Britain's most popular pastimes: every weekend sees around 200 wargames in action with hordes of people gathering at various hidden woodlands and indoor sites. Tournaments are held once a month and there is an annual Masters European competition.

The aim of the game is to capture the flag. On route to this climax two teams fight it out, killing as many of the opponents as possible by firing painful, plastic marbles filled with orange paint. Once splattered you're dead. While enduring the strategies of battle, customers (often sales teams or managers) have to deal with: "Genuine WWII tunnels and trenches; shootouts in Vietcong villages; blowing up the bridge, River Kwai style" or whatever speciality the particular site manager is offering.

The game "paintball" is an export from the USA, and although it has taken off with a bang in Britain (especially in the South and around the M 25 motorway) the rest of Europe has been slow to take it up. In some places it has even been outlawed. Paintball directors are anxious to avoid any connections being made between their game/sport and the action of war: one director explained to me that "if you played like this in real war, you'd be cut to pieces in seconds . . . except of course in Beirut; I think we could teach them a thing or two there." The cost per person varies from £50 to £100 for the day; the participants are primarily white males.

In this series, *Friendly Fire*, I aim to avoid capturing individuals on film as bizarre caricatures, as if in comic books. Instead I am looking to explore the very ordinariness of this subject. I act as if I am in a real war: photographing moments of action, tension and death; but this is a fiction and I am a fake. The battlefield images resemble "real" war pictures, except that they are enlarged to massive proportions. Photographs of the dead, made precious by their tiny size, rest in between the battlefields. The mythological characteristics of war are captured, briefly and uneasily.

I am interested in photographing ordinary people in ordinary places and looking for what is appearing instead of what is disappearing.

ANNA FOX

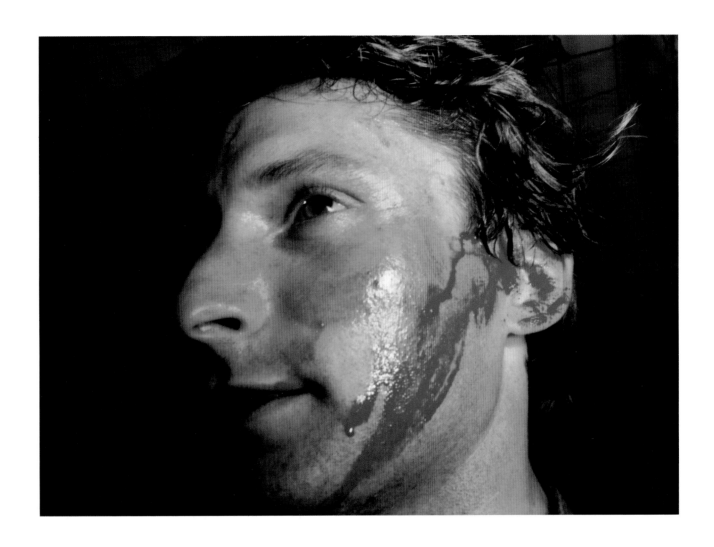

The Dead, 1990–94. From the Series "Friendly Fire – Weekend Wargames in Britain" (30 x 40 cm)

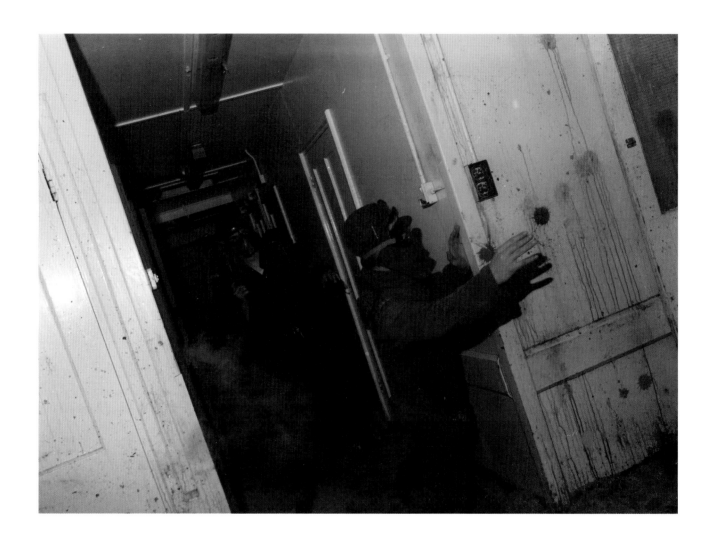

The Battlefields, 1990–94. From the Series "Friendly Fire – Weekend Wargames in Britain" (76 x 101 cm)

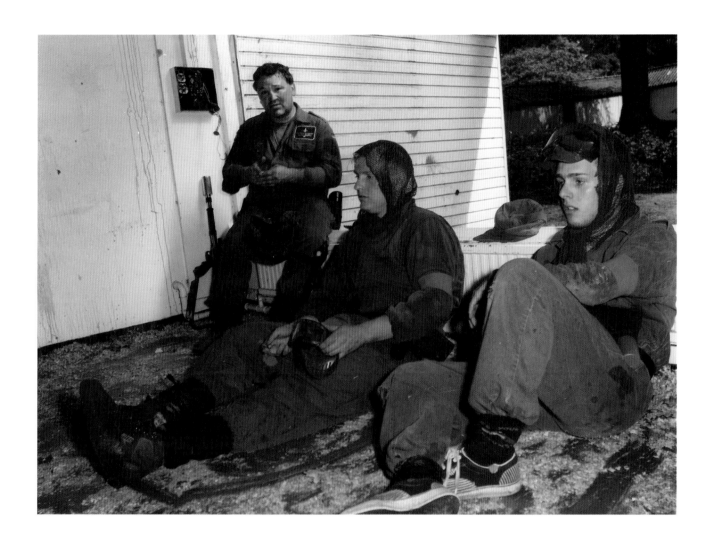

The Battlefields, 1990–94. From the Series "Friendly Fire – Weekend Wargames in Britain" (76 x 101 cm)

KIUSTON HALLÉ

DIE VORLIEGENDE SERIE entstand 1993 mit der Absicht, unsere "Akkumulationen", das heißt unsere kulturellen und materiellen Bezugssysteme, ins Bewußtsein zu rufen. Wir sind, glaube ich, von so zahlreichen Einflüssen geprägt, daß wir jede Form von Unschuld verloren haben und, um etwas Neues zu schaffen, diese Einflüsse auf die eine oder andere Weise assimilieren müssen.

Die "Akkumulationen" bilden einen natürlichen, folgerichtigen Schritt in meiner Entwicklung und haben ihren ersten Ausdruck in früheren Arbeiten wie den *Supports de confusion* ("Stützen der Verwirrung") gefunden, einer Bildfolge, die Zeitungs- und Fernsehsäulen zeigt. Im übrigen gehören die *Stützen der Verwirrung*, ebenso wie die hier vorgestellte Serie, in einen gedanklichen Zusammenhang, in dem es wesentlich um den Begriff des Körperlichen geht. Begonnen hatte ich nämlich mit Arbeiten über den menschlichen Körper (*Fotografien*, 1973–1978), gelangte dann zur Fotografie von Skulpturen (*Images sur Rodin et le Baroque* ("Bilder über Rodin und das Barock", 1980–1985), um schließlich mit den *Stützen der Verwirrung* die Skulptur selbst ins Bild zu setzen.

In der vorliegenden, insgesamt sechsteiligen Serie verwende ich wiederum Zeitungen als Träger meiner Arbeiten, doch entstehen daraus nicht mehr Bilder im eigentlichen Sinne, sondern Körper, dreidimensionale Objekte. Bei den Zeitungen handelt es sich um Wirtschaftszeitungen, die bekanntlich seitenlange Zahlenansammlungen in senkrechten Spalten auflisten. Auch wenn dieser Aspekt unsichtbar bleibt – ich bediene mich genau des weißen Zwischenraums, der von diesen Spalten gelassen wird –, so ist er doch konzeptionell wichtig für mich. Die Serie besteht aus Körpern, die wie "Energieadern" in den Raum ragen und eine Perspektive eröffnen, die in Frageform auf den tieferen Sinn meiner Absichten deutet: die Frage, wohin uns unsere "Akkumulationen" letztlich führen.

KIUSTON HALLÉ

THIS SERIES dates from 1993 and was taken with the aim of drawing attention to our "accumulations", that is to say, our system of cultural and material references. I believe we are marked by so many influences that we have lost any and every kind of innocence, and that in order to create something new we have to find some way to assimilate these influences.

The "accumulations" represent a natural and logical step in my development. They first found expression in earlier works of mine such as the *Supports de confusion* ("Supports of Confusion"), a series of photographs of columns made out of newspapers and televisions. *Supports de confusion* and the series shown here are related in concept in that they deal essentially with the physical. I began in fact with works on the human body (*Photographs*, 1973–1978), and went from there to photographs of sculptures, *Images sur Rodin et la Baroque* ("Images of Rodin and the Baroque", 1980–1985), in order, finally, to pictorially present sculpture itself, in *Supports de confusion.*

In these photographs, which in total make up a six-part series, newspapers are what I use as vehicles for my work. Through them, however, there emerge not pictures in the real sense, but physical forms, three-dimensional objects. The newspapers are business newspapers which, as we all know, list pages and pages of figures in vertical columns. Even though this aspect of the newspapers remains invisible – for I use those blank white spaces in between the columns – it is still conceptually important for me. The series consists of physical forms which rise up into the space like "energy veins", opening up a perspective which refers to the deeper meaning of my intentions: Where are our "accumulations" finally going to lead us?

KIUSTON HALLÉ

Untitled IV, 1993 (46 x 112 x 18 cm)

Untitled III, 1993 (46 x 112 x 18 cm)

Untitled II, 1993 (46 x 112 x 18 cm)

BERND HOFF

In den Jahren seit meinem Preisgewinn hat sich einiges in meiner Fotografie geändert. Ich bin weggekommen von inszenierten Bildern und angekommen bei schlichten, abbildenden Fotos, die eine einfache Sicht auf die Welt geben. All meine früheren Versuche mit großer Fotografie, mit sogenannten neuen Bildwelten und mutigen Sehweisen, endeten leider als aufdringliche Zwerge, die sich über Geschmack stritten. Sie waren nur Fotos, die nichts anderes zum Thema hatten als Fotografie. Mit eleganten Mitteln verwiesen sie auf nichts außer sich selbst. Wozu sollte das gut sein?

Als einziger Ausweg bleibt: der MTV-bunten Unterhaltsamkeit die monotone Gleichmäßigkeit der Welt entgegenzusetzen. Sozusagen: das Grundrauschen.

Die abgebildeten Fotos sind Teil einer Arbeit für den *Stern* aus den Jahren 1990–92 in den französischen Alpen anläßlich der Olympiade in Albertville.

Bernd Hoff

In the years after I won the prize, my photography underwent several changes. I departed from staged images and arrived at straightforward representational photographs which offer a simple view of the world. All my earlier attempts at "great" photography, with so-called new image-worlds and courageous new ways of seeing, ended, unfortunately, as obtrusive dwarfs squabbling about taste. They were photographs which had no other theme but photography. They referred, with elegant means, to nothing but themselves. And of what use is that?

There was only one way out: to set the monotonous uniformity of the world against colourful MTV entertainment; in other words, the underlying noise.

The photographs presented here are part of a work commissioned by *Stern* magazine in 1990–92 and were taken in the French Alps on the occasion of the Olympic Games in Albertville.

Bernd Hoff

Alpenlandschaft. Olympischer Slalomhang in Meribel, 1990 (180 x 220 cm)

Alpenlandschaft. Hotelkomplex in Tignes, 1990 (180 x 220 cm)

Alpenlandschaft. Hotels für Wintergäste in Meribel zur Sommerszeit, 1990 (180 x 220 cm)

Lewis – Thomas

Die Bilder der Serie *là et par là* entstanden durch Röntgenfotografie. Verschiedene Materialien – Aluminium, Blei, Draht und so weiter – werden in flachem oder gefaltetem Zustand, zerknüllt oder übereinandergeschichtet auf den Röntgenfilm gelegt oder über ihm aufgehängt und dabei in eine dreidimensionale Anordnung gebracht. Die Röntgenstrahlen durchdringen die unterschiedlichen Oberflächen und werden entsprechend der Dichte der jeweiligen Materialien absorbiert.

Während wir die Schichtung der Gegenstände auf den Bildern erkennen können, erliegen wir, durch das Arrangement bedingt, einer Sinnestäuschung hinsichtlich der Tiefendimension des Bildes, die den Anschein erweckt, in Abgründe zu blicken oder räumliche Anordnungen auf der Filmoberfläche wahrzunehmen. Um die erwirkte Räumlichkeit zu betonen, haben wir mit der Bildbegrenzung gespielt, die in Gestalt eines Ringsegments an die Wölbung des Himmels denken läßt.

Die Bildbegrenzung stellt einen Schnitt dar, der seinerseits zum Ausschnitt wird und der den Betrachter anleiten soll, einerseits einen erweiterten (gedanklich zum Ring geschlossenen) Raum zu sehen, andererseits eine Raumtiefe zu erfahren, die nur scheinbar von dem im Bild vorgegebenen Gesichtsfeld begrenzt ist und bis ins Unendliche weitergeführt werden kann.

Anordnung und Textur der das Bild gestaltenden Materialien vermitteln eine fremde, unbekannte Welt, die anderen physikalischen Gesetzen gehorcht als den uns bekannten – vom wissenschaftlichen Standpunkt aus analysiert vielleicht utopischen, poetischen.

Die menschliche Gestalt ist in fast allen Bildern der Serie gegenwärtig. Sie repräsentiert das menschliche Bindeglied bei der Entdeckung der Räumlichkeit im Bild und geleitet den Betrachter durch diese fantastische Welt zur hypothetischen Erforschung der unermeßlichen Räume.

Die Bilder wurden zu einer unbestimmten Zeit "aufgenommen". Im Titel der Serie evoziert das Wort "là" diesen unbestimmten Moment, während "par là" auf die Mittel verweist, die ihrerseits den Zugang zu Ort und Raum ermöglichen.

Zeit auch für den Reisenden – ob in Gestalt der im Bild repräsentierten Figur oder des Betrachters selbst –, die Segmente des Ringes und dessen Räume zu durchstreifen.

Lewis – Thomas

The images from the series *là et par là* are achieved by radiography; the first view of the subject is in the form of an X-ray film. This subject is, in fact, a construction made from diverse materials: aluminium, lead, wire, etc. Flat, folded, crumpled, or in layers, they are placed on the film itself or suspended above it, always forming a three-dimensional assemblage. The X-rays then penetrate the various surfaces and are absorbed in amounts according to the density of each material.

We can see the superimposition of the materials in the image. Through their arrangement we experience a trompe-l'oeil effect as regards the dimension of the depth which can either remind us of abysses or become spatial on the simple flat surface of the film. In order to emphasize the space obtained, we have played with the image delimitation which happens to be the segment of a ring, a ring which can neither deny its connotation nor avoid a resemblance with a celestial ring.

The outline of the image establishes a cut which, in turn, becomes a section. With the help of this section the spectator is summoned to observe on the one hand an extended space (mentally he could extend the vision of this segment to the point of closing this ring) and, on the other hand, to observe a space in depth which only appears to be limited by the field of vision given in the image but which could continue to infinity.

The conformation and texture of the materials composing the image convey a different world, unknown, with physical laws different from the ones we know and, perhaps, analysed from a scientific point of view, utopian and poetic.

The portrait of a figure is present in almost all the images in this series. It represents the human link, with the discovery of space vision, and a guide to the spectator leading him through this fantastic world and through the hypothetical exploration of incommensurable spaces.

These views are "taken" at an indeterminate time. In the title of the series the word "là" evokes this indeterminate moment in time, while "par là" refers to the means, that is to say, the media which in turn allow access to place and space.

Time also for the traveller, be it the figure represented in the image or the spectator himself, both wandering within the segments of the ring and through its spaces.

Lewis – Thomas

Là et par là, G 90-18/4, 1990 (95 x 95 cm)

Là et par là, G 90-2/2, 1990 (95 x 95 cm)

Là et par là, G 90-11/2, 1990 (95 x 95 cm)

81

LEIF LINDBERG

ALS ANTHROPOLOGISCHES WERKZEUG legt die Kamera die Regeln der Anonymität und des Ruhms in unserer Kultur auf neue Weise fest, zugleich bringt sie unsere Vorstellungen darüber durcheinander, was es heißt, einen Menschen zu kennen. Denn jede menschliche Begegnung kann durch das reduzierte, verkürzte, abstrahierte Abbild, das wir Schnappschuß nennen, wiedergewonnen und vergegenwärtigt werden – ein Umstand, dessen wir uns allzeit bewußt sind.

In einer früheren Arbeit von 1991 mit dem Titel *In Praise Of* ("Zum Lobe von") gab Leif Lindberg einer Serie von Schnappschüssen von Alltagsmenschen einen gleichsam heroischen und subtil ironischen Rahmen. Die Fotos zeigen Menschen, an denen nichts Besonderes hervorsticht, Fußgänger auf dem Weg nach Hause oder zum Einkauf... In der fertigen Arbeit sind sie aus dem Blatt ausgeschnitten, aus ihrer Umgebung herausgelöst und, auf weißem Hintergrund, mit einem leuchtendroten Passepartout versehen und gerahmt. Etwas Zufälliges, ja Wahlloses haftet den Fotos an – *en passant* aufgegriffene Personen, denen keine Zeit gelassen wurde, für die Kamera zu posieren. In der endgültigen Arbeit jedoch erscheinen die Personen durch die besondere Art der Präsentation voller Zielstrebigkeit, als überaus integre und selbstbewußte Persönlichkeiten, herausgehoben aus ihrer Durchschnittlichkeit, gepriesen und gefeiert.

Shelf, Oslo ("Regalbord, Oslo") bietet uns eine andere Gangart entlang der Straße. Wieder sind es Schnappschüsse von Menschen, die an der Kamera mehr oder weniger vorüberlaufen und von ihr erfaßt werden, ohne in eine aktive Beziehung zu ihr zu treten. Im Grunde verrät nichts an ihrer Erscheinung, warum gerade sie ausgewählt wurden. Was diese Fotografien und ihr Thema gleichermaßen auszeichnen, sind ihre Gewöhnlichkeit, ihre Schwerfälligkeit und ihr, im weitesten Sinne, Verhaftetsein mit dem Boden.

Die gezeigten Personen haben in einem bestimmten Augenblick in einer Stadt im Norden Europas einen bestimmten Raum eingenommen. In *Shelf, Oslo* erzählen ihre Fotografien, in Sequenzen wiederholt, von ihrem eigenen Raum entlang den Ausstellungswänden. Wie besetzen wir Raum? Gibt es Identifikationsprozesse in dieser Arbeit? Empathie? Das Auge der Kamera sieht, worauf es fokussiert ist. Das menschliche Auge hingegen mag fokussieren und doch nicht sehen. *Shelf, Oslo* von Leif Lindberg erforscht das Territorium zwischen dem menschlichen Auge und dem Auge der Kamera.

JAN-ERIK LUNDSTRÖM

THE CAMERA, AS AN ANTHROPOLOGICAL TOOL, redefines the conditions of anonymity and fame in human culture. It upsets and displaces our understanding of what it means to know a person. Any human encounter may be repossessed and replayed through that reduced, abbreviated, and abstracted representation known as the snapshot. And we live with that awareness.

In an earlier work, *In Praise Of*, from 1991, Leif Lindberg appended a certain heroic and subtly ironic framework to a series of snapshots of ordinary people. The photographs are of rather non-distinct persons walking the streets, on their way home from work, to the grocery store... In the completed works these figures are cut out from the page, literally lifted from their surroundings, and instead, matted on a white backdrop, given a bright red passe-partout, and framed. The photographs have an accidental, almost haphazard, quality about them, the characters caught *en passant*, never given time to address the camera, to pose. Nevertheless, in the completed works, with their particular framing, the subjects seem fraught with purpose, carrying themselves with great integrity and assertiveness, their ordinariness elevated, praised, celebrated .

Shelf, Oslo offers an alternative routing through the quintessential photographic stage which is the street. Again there are snapshots of people walking, more or less, past the camera. These persons are caught by the camera but they do not relate to it in any active way. Once again, they tend to be middle- or old-aged rather than young. They are not particularly photogenic in any standard sense. In fact there are few cues in their appearance which might explain why they are the chosen ones in this work. In all, both the photographs and their subject matter excel in being mundane, ordinary, somewhat dull and, in all senses of the term, pedestrian.

At one particular moment these persons occupied a particular space in a northern European city. In *Shelf, Oslo* the photographs of them, repeated, in sequence, narrate their own space along the gallery walls. How do we occupy space? Are there any processes of identification in this work? Empathy? The eye of the camera sees what it focuses on. The human eye may focus and yet not see. Leif Lindberg's *Shelf, Oslo* explores the territory between the human eye and the camera eye.

JAN-ERIK LUNDSTRÖM

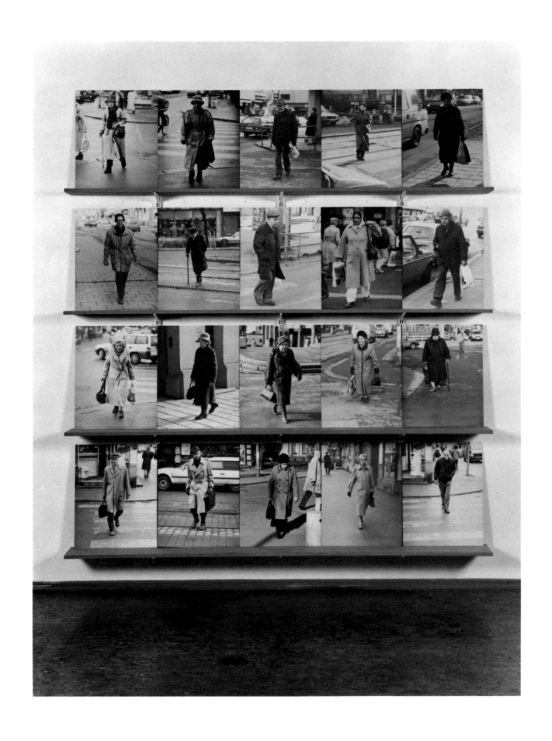

Hylla, Oslo / Shelf, Oslo. Detail, 20 of 120 parts, 1993 (120 x 100 cm)

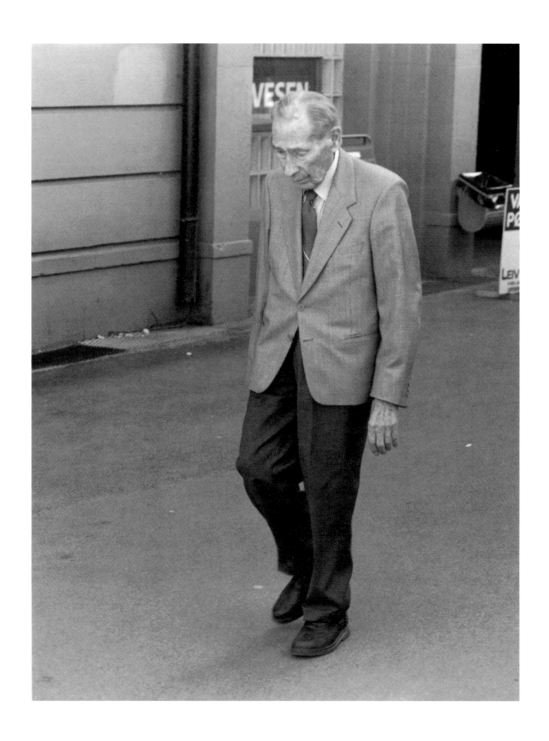

Hylla, Oslo / Shelf, Oslo. Detail, 1 of 120 parts, 1993 (26 x 19.5 cm)

Hylla, Oslo / Shelf, Oslo. Detail, 20 of 120 parts, 1993 (120 x 100 cm)

MARTÍ LLORENS

Es ist *ein* Raum, doch er könnte ein Symbol für viele sein und zu einer Metapher der Absurdität werden. Es ist *eine* Zeit, doch in ihr fließen Vergangenheit, Gegenwart und Zukunft zusammen. Und gemäß dieser Einheit/Mannigfaltigkeit finden wir in der Arbeit von Martí Llorens ganz unterschiedliche Stile und Verfahren, die alle auf einen einzigen geografischen Punkt gerichtet sind, um uns das Vergehen der Zeit nachempfindbar zu machen.

In den 30er Jahren war der Potsdamer Platz einer der neuralgischen Punkte Berlins. Mit der Bombardierung im Zweiten Weltkrieg wurde er zu einem gigantischen Trümmerfeld. Später verschwanden die Trümmer, und der Bau der Mauer verwandelte ihn in ein "Niemandsland". Und heute, nach dem Fall der Mauer, ist er ein hochbegehrtes Zentrum städtischer Entwicklungsmaßnahmen.

Räume, die verschwinden, Räume, die sich wandeln, wurden von Martí Llorens in akribischen Nachforschungen wiederentdeckt. Bilder, die bloße Dokumentationen hätten sein können – und bereits als solche überaus interessant gewesen wären –, wurden von seiner Sichtweise, seiner behutsamen und sorgfältigen Ausarbeitung geprägt (die enorme Zahl der Arbeitsstunden, die in jedes dieser Bilder einfloß, bringt uns wieder auf den impliziten Zeitbegriff).

Als Auftragsarbeit für die Galerie Bodo Niemann in Berlin entstanden, umfaßt das Projekt mehrere Teile: eine ursprüngliche Serie von Panoramabildern; eine Folge von Bildern auf Leinwand, die die "Erosion des Vergehens der Zeit" durchlitten haben und Objekte künstlerischer Manipulation sind; eine Gruppe kleiner Fotos mit anekdotenhaften Details; und schließlich eine Auswahl alter Fotografien und Postkarten, die als historische Bezugspunkte dienen. *Berlin – Potsdamer Platz* gibt eine neue Sicht auf einen symbolbehafteten Raum in einer symbolbehafteten Stadt, die heute von neuem vor einem vollständigen Wandel steht.

Jordi Fariñas

The space is one, but it could symbolise many others and become a metaphor of absurdity. The time is one, but within it past, present and future flow together. And so with this unity/diversity, we find in this work of Martí Llorens various styles and procedures, all centring on one very specific geographical point, pondering the passage of time.

In the '30s, Potsdamer Platz was one of the neuralgic points of the city of Berlin. With the bombing during the Second World War, this space became an immense heap of rubble. Still later, the rubble disappeared and the building of the Wall converted it into a "no-man's-land". Today, now that the Wall has been demolished, it has become a highly desirable centre for urban development operations.

Spaces that disappear, spaces that are transfigured all have been recovered by Martí Llorens in his scrupulous research. Images that might have been only documentary material – and for that reason alone they would be very interesting – passed through the sieve of his vision, of his slow and meticulous work (the enormous number of working hours involved in the production of any one of these pictures brings us back again to the concept of time in their inception).

Having originated on the basis of a commission to produce an exhibition for the Bodo Niemann gallery in Berlin, the work is made up of several parts: an initial set of panoramic images; a series of pictures on canvas that have suffered the "erosion of the passage of time" – objects of the author's manipulation; a group of small photographs of anecdotic details; and, finally, a selection of ancient photographs and postcards, serving as a point of historical reference. The result of *Berlin – Potsdamer Platz* is one of a new vision of an emblematic space, within an emblematic city, that is on the point of undergoing total transformation anew.

Jordi Fariñas

Berlin – Potsdamer Platz, 1993–94 (12 x 35 cm)

Berlin – Potsdamer Platz, 1993–94 (12 x 35 cm)

Berlin – Potsdamer Platz, 1993–94 (12 x 35 cm)

FRÉDÉRIC MARSAL

DIE WIEDERHOLUNG DES FAST IDENTISCHEN, die Vervielfältigung unseres Abbilds, der andere, der in uns einen Spiegel findet, führen zu einem virtuellen Begriff von Identität. Die unendlichen Selbstspiegelungen unseres Ichs lassen die Überzeugung von unserer Originalität und unnachahmlichen Einmaligkeit ins Wanken geraten. Hinter dieser Gesichter-Identität und angesichts der durch Nachahmung von Modellen, Darstellungen, Bildern und Trugbildern erlernten Identität wird die Ausübung von Kunst zu einem Monolog, der es ermöglicht, sich und die Dinge kennenzulernen.

Die Lösung dieses fotografischen Problems ist das Schweigen – weder das Nichts noch das negierte Nichts –, ist der Punkt, an dem wir alles aufgeben müssen, unsere Wertvorstellungen, unsere inneren und äußeren Stimmen, unsere Urteile. Die äußere Form erinnert auf beziehungsreiche Art und Weise an traditionelle Identifizierungsmethoden, an das Bertillonsche System*, um gleichzeitig in einigen Punkten davon abzuweichen: in der Lichtgebung, der Fragmentierung der Gesichter, der Blickrichtung. Die Beziehung zwischen Gegenstand und Betrachter, überlagert durch Wiederholungen und Rückgriffe auf bestimmte Bilder, wird zum Thema der Arbeit.

Dieser Versuch, die psycho-physische Realität aufzuzeichnen, war zunächst allein von sinnlichen Kriterien bestimmt, sowohl im Akt des Fotografierens als auch in der seriellen Anordnung der Bilder; erst danach bot sie den Boden für neue Erkenntnisse und Ideen.

FRÉDÉRIC MARSAL

* Alphonse Bertillon (1853–1914), Anthropologe und Kriminalist, erfand ein anthropometrisches System zur Identifizierung von Personen.

THE REPETITION OF THE NEARLY IDENTICAL, the multiplication of our image, the other finding a mirror in us, all bear witness to a virtual notion of identity. These endless self-reflections cause the originality of our ego and the conviction of our singularity to waver. Behind these face-identities, and confronted with these identities learned through imitation of models, representations, images and illusions, the practice of art becomes a monologue which enables us to learn something about ourselves and about things.

The solution of this photographic problem is silence – neither nothing nor negated nothing –, the place where we abandon everything: our values, our inner and outer voices, our judgements. This exterior form reminds one in a very associative way of traditional modes of identification, of the Bertillon system*, while at the same time differing from it in several ways: the light, the fragmentation of the faces, the direction of the gaze. The relationship between object and viewer is materialised, is overlaid with repetition and the recurrence of certain images, and becomes the theme of the work.

This attempt to register psycho-physical reality, either in the act of photographing or the way the series of photographs is assembled, was at first determined by sensual criteria and only later offered the basis for new insights and ideas.

FRÉDÉRIC MARSAL

* Alphonse Bertillon (1853–1914), anthropologist and detective, discovered an anthropometrical system for identifying people.

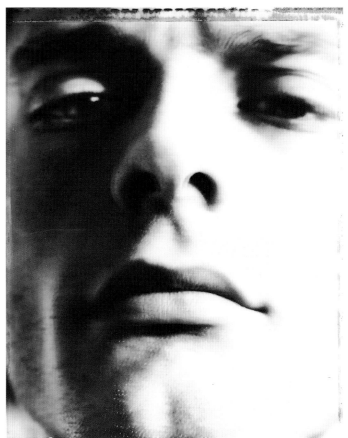

Ni rien, ni non rien, Paris, 1990 (23 x 18 cm)

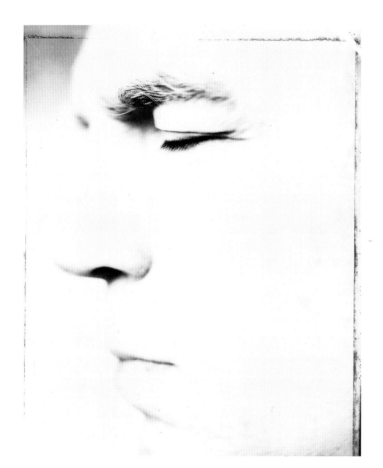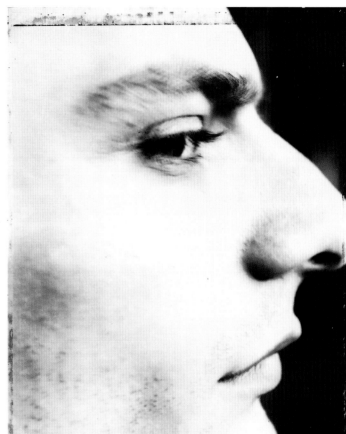

Ni rien, ni non rien, Paris, 1990 (23 x 18 cm)

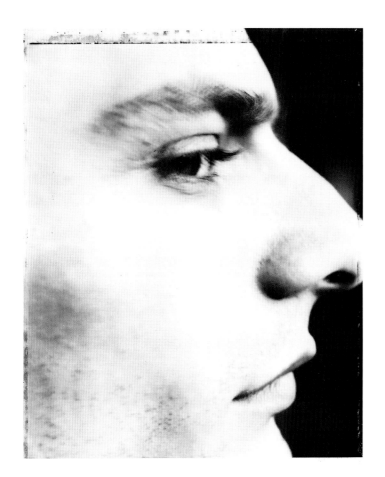

Ni rien, ni non rien, Paris, 1990 (23 x 18 cm)

ERWIN OLAF

DER HOLLÄNDISCHE KÜNSTLER Erwin Olaf, der sich in den letzten Jahren neben der angewandten und freien Fotografie immer intensiver mit dem Film auseinandergesetzt hat, gehört zu einer Generation europäischer Fotografen, die mit großer Opulenz die unterschiedlichen Sprachen der Mode-, Theater- oder Werbefotografie mischen und ironisch einsetzen. Das Medium dient der Inszenierung, wobei oft eine Serie von Aufnahmen die unterschiedlichen Protagonisten einer Geschichte, einer Fiktion, sei sie literarischer oder theatralischer Art, vorführen.

Olaf kam von einer dokumentarischen Fotografie, und die Tatsache, daß er für kommerzielle Auftraggeber, vor allem für das Theater arbeitete, hat lange den Blick darauf verstellt, daß er sich im angewandten und im freien Bereich die gleichen Freiheiten nahm. Was alle Arbeiten auszeichnet sind Bildwitz und Rückverweis auf Darstellungsformen der Kunst der Subkultur, der inszenierenden Modefotografie, des Theaters mit grotesken und absurden Zügen. Dabei gleitet das Groteske nie ins Bösartige ab, sondern es trägt eher Züge der Sinnenlust eines holländischen 17. Jahrhunderts, in das man sich zurückversetzt fühlt.

Im Unterschied zu den frühen Porträts und jenen Aufnahmen, in denen nur wenige Accessoires Aufschluß gaben über die jeweilig abgebildete Figur, entwickelten sich die späteren Arbeiten, von denen hier einige wiedergegeben sind, immer stärker zu *tableaux vivants*, die nur mit Hilfe zahlreicher für Haarschmuck, Mode und so weiter zuständigen Mitarbeiter möglich wurden. So wie es Aufnahmen gibt, die Ausdruck der Entkleidungslust waren, sind diese Aufnahmen Ausdruck eines Ver- und Bekleidungswahns. Die Freude am Fantastischen, Wunderbaren, und Seltsamen zeichnen dieses Werk aus. Dabei ist es nie glatt und eingängig, sondern immer voller Clownerie, Akrobatik und Sinnenlust. Es folgt keinem Schönheitsideal, sondern führt eher Gegenbilder vor, deren traumhafter Charakter deutlich ist.

Olafs Werk unterscheidet sich von der bizarren und nekrophilen Welt eines Joel Peter Witkin oder den tiefenpsychologisch verrätselten Alpträumen eines Arthur Tress. Die Leichtigkeit, mit der Erwin Olaf eine künstliche Welt erschafft, deren formale Herkunft aus den verschiedenen Funktionsbereichen der Fotografie der Werbung, der Mode, der Pornografie und des Theaters er nicht verheimlicht, deren Sprachen er jedoch abenteuerlich mischt und ironisch einsetzt, ist Erbe seiner Generation.

PETER WEIERMAIR

THE DUTCH ARTIST Erwin Olaf, over the past years, has been involved not only in applied and free photography, but also, increasingly, in film-making. He is one of a generation of European photographers who makes opulent use of the various photographic languages: that of fashion, of theatre, and of advertising. He uses the medium of photography in support of his staged productions, often presenting a series of photographs so as to introduce the different protagonists of a story or a fiction – be it of a literary or theatrical nature.

Olaf's initial preoccupation was with documentary photography. The fact that he performed commercial work, principally for the theatre, has blinded many to the reality that he took the same kinds of liberties in his commercial as in his independent work. What distinguishes all his work is a sense of pictorial humour and a constant reference to the representational forms prevalent in the art of subcultures, of staged fashion photography, of the theatre – with their grotesque and absurd traits. Even so, the grotesque features in his work never appear malicious, but only serve to evoke the sensuality of 17th century Holland, to which the viewer feels he has been transported.

In contrast to his early portraits and to those photographs which required only few accessories, his later works, some of which are reproduced here, developed more and more into *tableaux vivants*. This was made possible with the help of numerous assistants, one responsible for hair ornaments, one for clothing et cetera. And just as there are certain photographs which lend expression to the desire to undress, these photographs are the expression of a mania for fancy-dress and disguise. They are imbued with a delight in all that is fantastic, mysterious and strange. They are never merely slick and glib, but full of clownish and acrobatic sensuality. Never subscribing to an ideal of beauty, they prefer instead to present counter-images which have a clearly dream-like character.

The subject matter of Olaf's work differs from the bizarre and necrophile world of a Joel Peter Witkin or the psychologically puzzling nightmares of an Arthur Tress. Erwin Olaf creates an artificial world, making no secret of its formal origins in the functional photographic realms of advertising, fashion, pornography and theatre, but mixing and matching their languages with a keen sense of adventure and irony, and this he does with a lightness which is the inheritance of his generation.

PETER WEIERMAIR

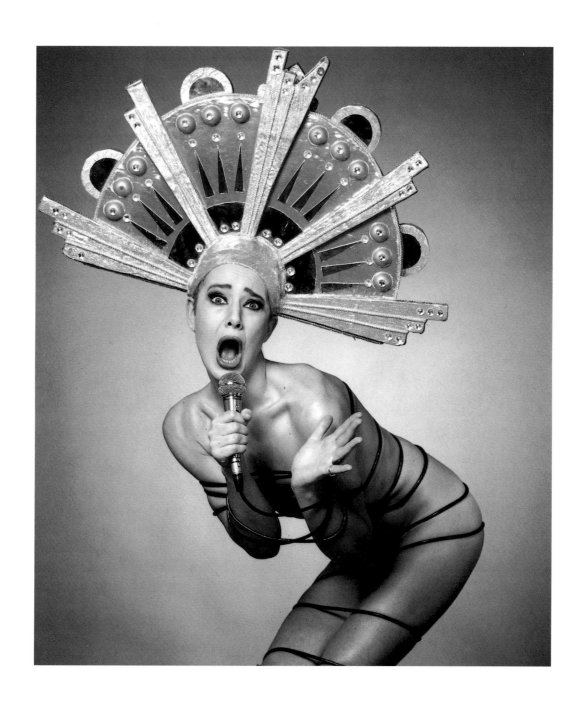

La Pat, 1988. From the Series "Girls" (120 x 100 cm)

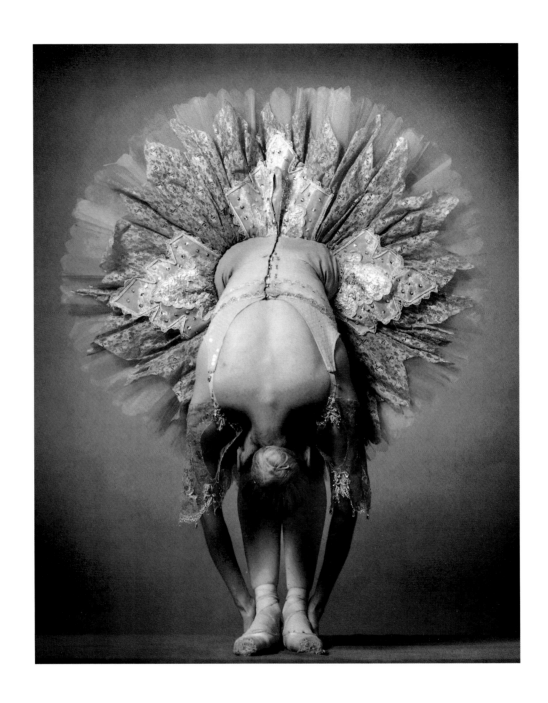

Marieke Simons, 1988. From the Series "Girls" (120 x 100 cm)

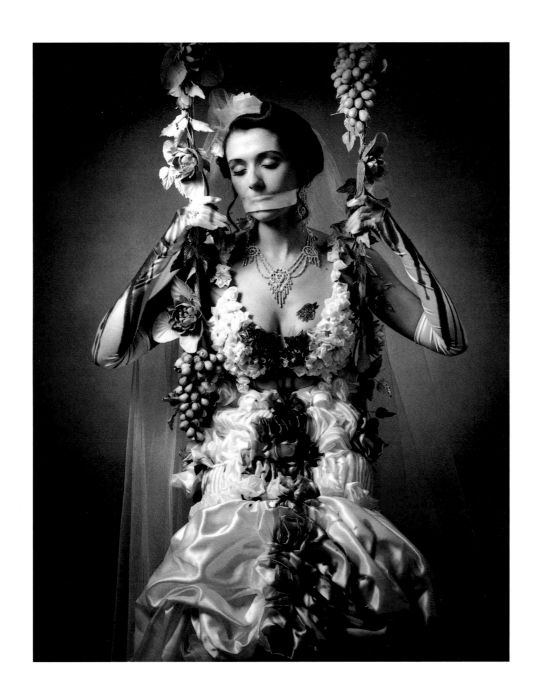

Sarah de Roo, 1991. From the Series "Girls" (120 x 100 cm)

MARTIN PARR

DIE HIER GEZEIGTEN FOTOGRAFIEN Martin Parrs handeln von der Vielschichtigkeit des persönlichen Geschmacks zu Hause, in den eigenen vier Wänden. Sie entstanden in Verbindung mit der Fernsehserie *Signs of the Times,* deren Vorbereitungen im Frühjahr 1990 begannen und bis in den Herbst 1991 hinein dauerten. In regionalen und überregionalen Zeitungsannoncen baten wir die Öffentlichkeit, uns Informationen zu allen Aspekten des persönlichen Geschmacks im eigenen Heim zukommen zu lassen – mit zunächst mäßigem Erfolg. Es ist eine alte Fernseherfahrung, daß diejenigen, die gern ins Fernsehen möchten, oft weniger interessant sind als die, die es nicht möchten. Doch vermittelten uns die Interessenten nicht selten an Freunde, Nachbarn und Verwandte weiter, zu denen fruchtbare Kontakte geknüpft werden konnten.

Signs of the Times erhebt nicht den Anspruch einer Theorie des persönlichen Geschmacks oder einer wissenschaftlichen Studie über den Einrichtungsstil der Briten. Die rund achtzig gefilmten Personen wurden landesweit unter 2 000 interviewten Interessenten ausgewählt und ohne weiteren Kommentar vorgestellt. Sie repräsentieren einen guten Querschnitt des zeitgenössischen Geschmacks, ausgewählt nach so verschiedenartigen Kriterien wie Lebensalter, Geschlecht, ethnischer Zugehörigkeit, sozialer Stellung, Wohnregion oder Persönlichkeitstyp. Von den fünfzig von uns gefilmten Haushalten fotografierte Martin Parr dreißig, nachdem er unsere Filmaufnahmen und die Niederschriften der Interviews durchgesehen hatte. Generell gaben wir dem gewöhnlichen, unspektakulären Geschmack den Vorzug vor dem exotischen, und es war uns immer wieder eine Genugtuung, wenn wir gefragt wurden, "Warum filmen Sie uns? Wir sind doch ganz normale Leute, oder?"

Die Filme wie auch die Fotos sind zweifellos voyeuristisch, doch sollten sie, über das bloße visuelle Vergnügen hinaus, eine Art Komplizenschaft zwischen Betrachtern und Betrachteten herstellen. Ihr Wert liegt in der Qualität der Beobachtung und den von ihnen angeregten Reflexionen über das Phänomen des persönlichen Geschmacks: Was auf den ersten Blick trivial erscheint, entpuppt sich bei genauerem Hinschauen als elementarer Ausdruck privater und sozialer Identität. Und wie die Fotografien von Martin Parr bezeugen, geben die trivialen Geschmacksäußerungen nicht zuletzt beredten Aufschluß über die Ausübung häuslicher und kultureller Macht im Großbritannien von heute.

NICHOLAS BARKER

THE COMPLEXITIES OF PERSONAL TASTE as expressed in the home are the subject of these photographs by Martin Parr and the television series, *Signs of the Times,* which they accompany. Research for the series began in the spring of 1990 and continued until the autumn of 1991. Advertisements were placed in the national and local press appealing to members of the public to volunteer information about all aspects of their taste in the home. Initially, these appeals had only limited success. It is a truism in television research that people who want to be filmed are often less interesting than people who don't. However, respondents frequently put us onto their friends, neighbours and relatives, among whom fruitful contacts were made.

Signs of the Times makes no claims to being a scientific survey of taste in the British home, nor does it advance a theory of personal taste. The eighty or so people featured in the films were selected from 2,000 interviewed nationwide, and are presented without commentary. In my view they represent a broad cross-section of contemporary taste selected according to a wide range of criteria, foremost of which were lifestage, gender, ethnicity, social class, region, and personality type. Of the fifty households we filmed, Martin Parr photographed thirty, having first viewed our film rushes and transcripts of the interviews. Ordinary and unexceptional tastes were generally chosen in preference to the exotic, and we were gratified by the frequency with which people enquired 'why are you filming us? We're not that different, are we?'

The films and still photographs are undoubtedly voyeuristic. However, their objective was to transcend mere visual pleasure and establish a sense of complicity between viewers and the people they were invited to gaze upon. The value of this work, such as it is, lies in the quality of its observation and the reflections on personal taste which it stimulates. Apparently trivial matters of taste, when peered at carefully, reveal crucial expressions of private and social identity. And as Martin Parr's photographs testify, they also say much about the exercise of domestic and cultural power in contemporary Britain.

NICHOLAS BARKER

I remember very clearly when this carpet went down
because it came over television that President
Kennedy was assassinated

Signs of the Times – A Portrait of the Nation's Tastes, 1992 (45 x 45 cm)

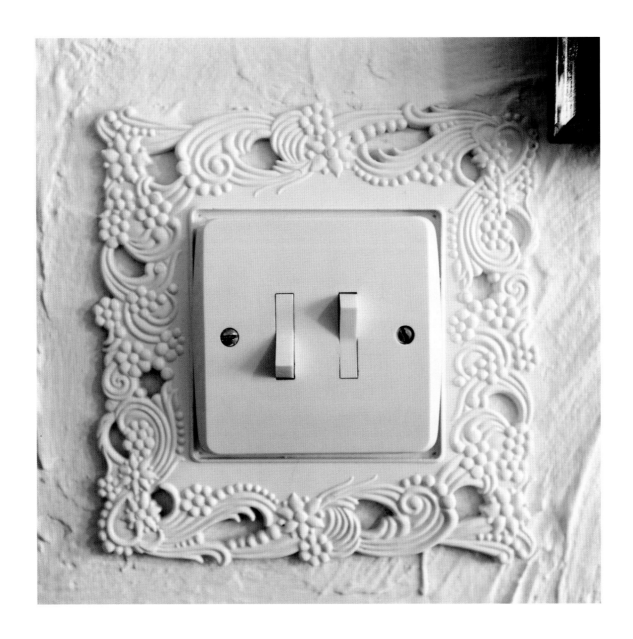

We wanted a cottagey
stately home kind of feel

Signs of the Times – A Portrait of the Nation's Tastes, 1992 (45 x 45 cm)

I get such pleasure from them every
day when I sit in the bath

Signs of the Times – A Portrait of the Nation's Tastes, 1992 (45 x 45 cm)

Jens Rötzsch

Der Ausgangspunkt im Schaffen von Jens Rötzsch ist der Fotojournalismus, wenngleich seit 1986, dem Ende des Studiums an der Hochschule für Grafik und Buchkunst in Leipzig, die Weichen in andere Richtung gestellt schienen. Sujets wie Landschaften und Stilleben in den Wechselwirkungen des Lichts und der Farbe waren zunächst vorherrschend. Doch die mit der ersten größeren Arbeit, dem Diplom, gesetzten Prämissen wurden schon bald aufgehoben. Das Zusatzstudium in Leipzig und an der Budapester Hochschule für Angewandte Kunst und Design zwischen 1986 und 1989 ließen Anregungen entstehen, die sich für die künftige Arbeit als richtunggebend erweisen sollten.

Die im Bereich der Farbe erkundeten Ausdruckswerte wurden mit konsequenter Radikalität in die dokumentarische Wirklichkeitssegmentierung des DDR-Alltags eingebracht. Es entstand zwischen 1987 und 1991 die Folge *Protokoll-Strecken*, mit der beziehungsreichen Ergänzung "Bilder aus dem gesellschaftlichen Leben". Das damals aufsehenerregende Projekt der Dokumentation von Festen, Ritualen und politischen Großveranstaltungen in der DDR und in Ungarn stellte eine Verbindung von Massenveranstaltungen, Aufmärschen und Macht vor der Gegenwartskulisse des real existierenden Sozialismus her. Wie nur wenige Fotografen hat Jens Rötzsch das Zusammenspiel verordneter Staatsfeste und Systemerhaltung als Ausdruck von Herrschaftsansprüchen in Bildern von zum Teil radikalem Farbrealismus kommentiert und karikiert. Auch in den Umbrüchen nach 1989 hat sein sezierender Kamerablick nicht nachgelassen, die sich etablierenden Strukturen im Osten Deutschlands aufzuspüren.

Die Fähigkeit, Menschen in Beziehung zu ihrem gesellschaftlichen Umfeld zu setzen – wo immer auf dieser Welt –, gehört zu den ganz besonderen Qualitäten von Jens Rötzsch. Beispiele dafür sind unter anderem die *Gruppenbilder ethnischer und nationaler Minderheiten in Ungarn*, die *Feste in Portugal* sowie die auf Reisen nach Vietnam, Mallorca und Großbritannien entstandenen Bilder, in denen neuerlich die Vorliebe zu großen, dominanten Formen, vor allem in Beziehung zur Landschaft, hervortritt. All diese Serien und Zyklen, die zwischen 1987 und 1994 entstanden sind, offenbaren gleichwohl eine durchgehende fotografische Haltung. Jens Rötzsch hat bereits sehr früh zu dieser für ihn bemerkenswerten Bildsprache gefunden, die sich inzwischen als unverwechselbarer Personalstil manifestiert.

Ullrich Wallenburg

The point of departure of Jens Rötzsch's work is photojournalism, even though after his studies at the Hochschule für Grafik und Buchkunst in Leipzig in 1986 his course seemed to have been set in another direction. At first subjects such as landscapes and still-life studies in the interaction between light and colour dominate. But the premises laid down in his first larger work, for the diploma, were soon superseded. Further studies in Leipzig and Budapest between 1986 and 1989 offered stimuli which were to prove decisive for his future work.

The expressive values discovered in the realm of colour were introduced consistently and radically into the documentary segmentation of the reality of everyday life in the GDR. Between 1987 and 1991 the series *Protokoll-Strecken* ("Protocol Series") emerged, along with the supplementary and highly associative "Pictures of Social Life". The project to document festivals, rituals and large-scale political events in the GDR and Hungary, and which caused a sensation at the time, made a connection between mass gatherings, parades and power, against the backdrop of Eastern Block communism. Like few others, and in images which are sometimes characterised by a radical colour realism, Jens Rötzsch has commented on and caricatured the interplay between prescribed state festivals and the maintenance of a system as an expression of aspiration to power. Even in the turmoil since 1989, the dissecting eye of his camera has not ceased to track down the structures establishing themselves in the East of Germany.

The ability to set people in a relationship to their social environment – wherever in the world this may be – is one of Jens Rötzsch's particular gifts. Examples of this are, among others, *Gruppenbilder ethnischer und nationaler Minderheiten in Ungarn* ("Group Photographs of Ethnic and National Minorities in Hungary"), *Feste in Portugal* ("Festivals in Portugal"), and the photographs taken on his travels in Vietnam, Majorca and Great Britain, photographs in which recently a preference seems to have emerged for large dominant forms, above all in connection with landscapes. Nonetheless, all these series and cycles taken between 1987 and 1994 bear witness to a particular recurring approach in his photography. Jens Rötzsch gained access at an early stage to this remarkable pictorial language which in the meantime has become manifest as his distinctive personal style.

Ullrich Wallenburg

Stonehenge, 1993 (50 x 50 cm)

Punta Portales, Mallorca, 1993 (50 x 50 cm)

Corte, Korsika, 1994 (50 x 50 cm)

Eva Schlegel

Die hier gezeigte Installation entstand aus der Auseinandersetzung mit Raum, vor allem mit dem Phänomen des immateriellen Raums. Menschengroße Glasplatten, bedruckt mit unscharfen Schriften, verkörpern als Ideenträger den unsichtbaren Gedankenraum des Lesens. Fotografiert wurden theoretische Texte, Interviews, Erzählungen, wissenschaftliche Abhandlungen und Lyrik, dabei wurde darauf geachtet, daß das Erscheinungsbild nicht zu unterschiedlich ausfiel, um vergleichende ästhetische Wertungen zu vermeiden. Wichtig war zudem, die Textseiten nicht wie Bilder zu präsentieren, sondern relativ ungeordnet an die Wand zu lehnen, das heißt, den Galerieraum wie ein Depot zu benutzen. Wenn man die Installation betritt, hat man das Gefühl, sich in einem losen Buch zu befinden, man identifiziert die Tafeln als Textseiten, obwohl diese vom primären Informationsgehalt befreit sind. Mich interessierte vor allem die Frage (nach der Struktur von Wahrnehmung und Text): Was macht einen Text sofort erkennbar als solchen, wenn er nicht lesbar ist, und wodurch unterscheiden sich Text und Bild?

In einem zweiten Raum gegenüber befand sich eine Bibliothek mit 1 000 Büchern, auf die die Leute zugingen und ein Exemplar herausnahmen, um es zu lesen. In diesem Buch befinden sich alle "Textmotive" der Installation, aber traditionell angeordnet, mit Satzspiegel, in klassischem Rot und Taschenbuchformat. Hier stellt sich sofort eine intime Situation ein, der Leser und das Buch, die Realität wird ausgeblendet, man ist im Buch. Aber auch hier Irritation durch die Unschärfe der Schrift. In der Hälfte der Auflage wurden unscharfe Bilder mit unscharfen Texten überlagert, um die unterschiedlichen Sehgewohnheiten zu betonen: Ein unscharfes Bild verfügt über kunstgeschichtliche Zuordnungen, ein unscharfer Text über keine Konnotation, beide aber über unterschiedliche räumliche Ausdehnung.

Eva Schlegel

This installation emerged out of a concern with space, above all with the phenomenon of immaterial space. Man-sized glass plates printed with blurred texts embody, as carriers of ideas, the invisible thought-space of the act of reading. Theoretical texts, interviews, short stories, academic treatises and lyrical poetry were photographed, with attention given to ensure that the individual appearances of the different texts were none too different, so as to avoid comparative aesthetic evaluations. Another important consideration was displaying the pages of text not as pictures, but rather laying them against the wall in a relatively disorderly manner, i.e. using the gallery space more as storage area. On entering the installation one had the feeling of being in a loose-leaf book; one could identify the panels as pages of text although they had been freed of their primary informational content. Of particular interest to me was the question (of the structure of perception and text): what makes a text immediately recognisable as such when it is not legible, and in what way does a text differ from a picture?

A second, opposite room contained a 1,000 book library which people could approach and from which they could remove a copy to read. This book contains all the "text motifs" of the installation, but presented in a traditional manner, with a type area, printed in classical red, and in paperback format. Immediately an intimacy arises between the reader and the book. Reality fades out, the reader is in the book. But here too there is a certain irritation because the text is blurred. In half of the books blurred texts were superimposed on blurred pictures, emphasising the different modes of looking involved: a blurred picture has at its command the classifications of art history, a blurred text has no connotations at its command, the two of them, however, have differing spatial extent.

Eva Schlegel

Installation View, Galerie Krinzinger, Vienna, 1993 (180 x 113.5 each)

Installation View, Galerie Krinzinger, Vienna, 1993 (180 x 113.5 each)

Installation View, Galerie Krinzinger, Vienna, 1993 (180 x 113.5 each)

ERASMUS SCHRÖTER

ERASMUS SCHRÖTER IST EIN SPÄHER, getrieben von lustvollem Spürsinn und stets unvermeidbar nahe am Abenteuer. Eine in den Jahren 1993 und 1994 entstandene Serie von 15 Fotos mit dem Titel *Die Flotte* ist ein Paradebeispiel für Schröters Art, auf die Pirsch zu gehen und maschinengestützt ein paar Bilder zu produzieren, die ohne geschmäcklerische Oberflächenästhetik auskommen und geradewegs in "the real politics of art" hineinstoßen. Was ist zu sehen, und wie vollzieht sich dieser Prozeß?

Im vorliegenden Fall arbeitet der Künstler mit Schwarzweißbildern im Panoramaformat (zwischen 58 x 150 und 58 x 120 cm), die die Wracks eines Schiffsfriedhofs vor Peenemünde (Ostseeinsel Usedom) zeigen. Hochgradig kulturell geformt, nämlich durch militärischen Beschuß, entbehren die bizarren Metallkörper jeder eingebildeten Natürlichkeit. Innerhalb von zwei Sessions unter höchst schwierigen Bedingungen war Erasmus Schröter mit tatkräftiger Unterstützung seines Freundes Bernd Hiepe in die seit gut fünfzig Jahren als militärisches Sperrgebiet deklarierte Zone eingedrungen und hatte sich seine Perspektiven gesucht. Eingekeilt zwischen Munitionsblindgängern und irritiert vom ständigen Schlingern des Bootes organisierte er seine Bildproduktion, die dem Betrachter nichts mehr von der verlockenden und zugleich gefährlichen Tour mitteilen und sein Augenmerk nun ganz auf die Darstellung richten. Es kann nicht an der das Foto luftdicht einschließenden Plexiglaslaminierung liegen, daß die Bilder nicht mehr transportieren als einen wohlplazierten Kanon im Zentrum der Schröterschen Kunstordnung. Vielmehr hat dieses Faktum zu tun mit einem konzeptionellen Reduktionismus, der Schröters Bilder von allem narrativen Beiwerk und auch von der theatralischen Opulenz seiner *War Buildings* von 1993 reinigt und damit den Bogen schlägt zu einem Moment der Direktheit, wie sie bereits den frühen, noch in der DDR entstandenen Bildern Schröters eigen war. Doch im Unterschied zum Flair der resignierenden Unlust unter Erichs Cordhütchensozialismus, das die frühen Arbeiten vom Anfang der 80er Jahre transportieren, artikulieren Schröters vom Zielschießen der NVA zerbröselte Schiffsruinen nun eher die schiere Existenz der Dinge, Zerstörungsverhältnisse sezierend, nüchtern und unbeeindruckt von Seemannsgarn und Heldentod.

CHRISTOPH TANNERT

ERASMUS SCHRÖTER IS A SCOUT, driven by a pleasurable instinct, and always unavoidably close to adventure. *Die Flotte* ("The Fleet"), a series of 15 photographs dating from 1993 and 1994, is a perfect example of how Schröter goes stalking and how, machine-aided, he produces pictures which do without fashionable surface aesthetics and go straight to the very heart of "the real politics of art". What is there to be seen, and how does this process take place?

For this series the artist worked in black-and-white, with a panorama format (between 58 x 150 and 58 x 120 cm). The photographs depict wrecks in a ships' cemetery off Peenemünde (Baltic island of Usedom). These bizarre metal bodies lack any imaginable naturalness, their contours being the result of military bombardment and thus highly culturally determined. In two sessions under the most difficult of conditions, Erasmus Schröter, with the active support of his friend Bernd Hiepe, forced his way into this area – which for a good 50 years has been declared a prohibited military zone – on the look out for his perspectives. He organised his photographic production wedged between unexploded shells and aggravated by the constant lurching of the ship. The photographs mediate to the viewer nothing of the tempting and at the same time dangerous tour, directing our full attention merely to the presentation. That the photographs fail to transport more than the Schröter canon, strategically central to his artistic order, has less to do with their airtight plexiglass lamination and more with the conceptual reductionism which purifies Schröter's pictures both of all narrative accessories and of the theatrical opulence of his *War Buildings* of 1993. They are thus linked with a moment of directness characteristic of his early photographs taken in the former GDR. But in contrast to the flair of the resignation and lack of enthusiasm prevalent under Erich Honnecker's particular brand of socialism and transported by Schröter's early works at the beginning of the 80s, his ruins of ships crumbling under the target practice of the NVA (National People's Army) now articulate more the sheer existence of things, analysing conditions of destruction, with sobriety and unimpressed by seamen's yarns or heroic notions of death.

CHRISTOPH TANNERT

Flotte VIII, 1993 (70 x 150 cm)

Top: Flotte IV, 1993 (58 x 149 cm); bottom: Flotte II, 1993 (58 x 150 cm)

Top: Flotte VII, 1993 (50 x 150 cm); bottom: Flotte I, 1993 (58 x 150 cm)

Mikołaj Smoczynski

Smoczynskis erste Arbeiten an seiner Serie *The Secret Performance* ("Die geheime Performance") gehen auf das Jahr 1983 zurück, in eine Zeit also, da sich die polnischen Künstler angesichts des über das Land verhängten Kriegsrechts in einer besonderen Isolation befanden. Damals begann er, innerhalb der vier Wände seines Studios, seine eigene Realität zu schaffen. Der schwarze Boden des Raumes, die Staubstreifen, die glänzenden Spuren verschütteten Wassers und das durch das Fenster einfallende Licht waren die Mittel, mit denen er seine mysteriöse Schau arrangierte – eine Schau nicht für die Öffentlichkeit, sondern allein für die Kamera. Seine Schwarzweißfotos vergrößerte er auf das Format riesiger Gemälde. Begegnet man ihnen heute in Ausstellungen, erinnern sie tatsächlich an bemalte Leinwände, und die Staubstreifen, die den fotografierten Oberflächen Struktur verleihen, erscheinen wie ausdrucksvolle Pinselstriche.

Diese Nähe zur Malerei ist bei einem Künstler, der eine Ausbildung zum Maler hat, nichts Verwunderliches. Smoczynski bedient sich indes einer Vielzahl von Techniken und Ausdrucksformen, zu denen neben Fotografie und Malerei auch die Webkunst, die Bildhauerei und die Installationskunst zählen. Soweit sich der Künstler der Fotografie bedient, tut er dies im Bewußtsein ihrer Autonomie und spezifischen Sprachlichkeit: Seine Bilder der Serie *The Secret Performance* sind reine Fotografie, die die Eigenschaften des Mediums bis an die Grenzen ihrer Möglichkeiten nutzt.

In dem hier vorgestellten Teil der Serie arbeitet Smoczynski mit großen Flächen von sattem, subtil differenziertem Schwarz, die den dramatischen Aspekt der Bilder hervorheben und sie an Mondlandschaften, an abstrakte Kompositionen oder *peinture de la matière*, an imaginäre architektonische Räume erinnern lassen. Gleichwohl will diese Fotografie kein Ereignis wiedergeben und keine Botschaft übermitteln. "Es gibt keine Ereignisse mehr", sagt der Künstler, "keine Erinnerung an sie, geschweige denn Erinnerungen an die Erinnerung. . . Ich wiederhole und wiederhole ein und dasselbe auf ähnliche Art und Weise. Nicht, um irgend etwas zu beweisen, und auch nicht, um etwas zu entdecken. Ich wiederhole es, weil ich etwas erwarte, dessen Existenz ich fühle oder das in meinen Erwartungen existiert und sich ganz von allein offenbaren wird."

Barbara Kosinska

Smoczynski's first works in *The Secret Performance* series, which is still in progress, date from 1983, when the artistic community found itself peculiarly isolated owing to the dramatic circumstances of the martial law period in Poland. At that time, within the four walls of his studio, Smoczynski began to create his personal reality from the black floor of the room, streaks of dust, glossy traces of spilled water, and light penetrating from the window. The mysterious show that he arranged was not intended for the public but exclusively for his camera. He enlarged his black-and-white photos to the size of huge paintings. Indeed, when seen at exhibitions the large pictures are reminiscent of painted canvases, and the streaks of dust contributing to the texture of the photographed surfaces are like expressive strokes of the brush.

This affinity with painting is not surprising in the case of an artist who is a painter by education. Yet he expresses himself with various techniques and forms. In addition to photography, he practices painting, weaving, sculpture, and installation art. In his choice of photography as a means of expression, the artist is aware of its autonomy and its distinct language: His enormous images in *The Secret Performance* series represent pure photography, highly appealing in its use of the properties of the medium almost to the limit of their potentialities.

In the part of the series presented here, Smoczynski works with large surfaces of saturated, subtly varied black, which give the images a particularly dramatic expression. The images bring to mind lunar landscapes, abstract compositions or *peinture de la matière*, and imaginary architectural spaces. But this photography does not relate anything, does not refer to events or convey any message from beyond photography. "There are no more events," the artist says. "There is no memory of them, nor even memories of memory . . . I keep repeating the same thing in similar ways. Not in order to prove anything, and not in order to discover anything. I repeat it because I expect something, the existence of which I sense or which exists in my expectations, to be revealed all by itself."

Barbara Kosinska

The Secret Performance – Coda, 1994 (105 x 120 cm)

The Secret Performance – IV, Part I, 1994 (105 x 120 cm)

The Secret Performance – iv, Part ii, 1994 (105 x 120 cm)

BEAT STREULI

BEAT STREULI hat in den vergangenen Jahren in Rom, Paris und New York gelebt. Das natürliche Umfeld seines Werks ist die Großstadt. Von ihr erstellt er, überwiegend in Schwarzweiß, physiognomische Splitter. Die Metropole ist nicht mehr Geheimnis, Dunkel oder Gefahr, noch kochender Dschungel oder Labyrinth. Sie erschließt sich auch nicht mehr im Gegenbild einer verlorenen Natur. Der zentrale Zivilisationstyp der westlichen Moderne ist selbst natürlich geworden. Das Leben der Bewohner läßt das Alltägliche, das Bekannte und Gewöhnliche zu einer schwer faßbaren, sich ständig wandelnden und dennoch erkennbaren Form gerinnen. Identifikation zwischen City und City leisten die Details und der Rhythmus, dem sie unterliegen.

Diesem Strom nähert sich Beat Streuli wenn möglich mit Schnappschüssen, die er vom Gebot der Zuspitzung befreit. So sieht man keine entscheidenden Augenblicke, die Situationen auf den Punkt bringen, eine Geschichte erzählbar machen, eine Gesellschaftsstruktur, eine Politik oder einen Habitus beschreiben. Es gibt kein erkennbares Ganzes, auf das sich verweisen ließe. Die Ausschnitte bleiben so sehr Teil des Geschehens, dem sie entrissen sind, daß sie wie ein Sog darauf verweisen. Streuli zwängt die Figuren ins Bild, läßt uns Blickrichtungen folgen, verwischt dahineilende Körper, bis das, was zu sehen ist, seine Ausweitung fordert über die Ränder der 137 x 201 cm großen Formate hinaus oder zum nächsten Bild, gerade so, als wären die in räumlicher Folge gehängten Arbeiten Teil eines abrollenden Films, in dem die Menschen vom Close-up wieder in die Totale zurücksinken und verschwinden. Streulis Großstadt scheint weder einen Narzißmus der Selbstdarstellung noch ein Leiden an der Menge zu erlauben. Wenn sich Bedeutsames aus dem Gewöhnlichen abhebt, dann nur durch Wiederholung, kleine Abweichungen und den Vergleich.

Zeigten die Straßenbilder aus Paris vor allem Schriftzüge (Einkaufstüten, Kleidung, Werbung, Schilder, Autonummern) und das Gitterwerk aus orthogonalen Sichtbarrieren und trennenden Glasspiegelungen, hinter denen die Menschen nah, aber unnahbar waren, so gilt auf den New Yorker Bildern der letzten drei Jahre ganz unmittelbar das erste Interesse des Flaneurs Streuli der großstädtischen Menschenmenge. Der konstruktiv fixierende Blick löst sich auf in einer Bewegung, die Passanten und Fotografen gleichermaßen umfaßt.

GERHARD MACK

OVER THE PAST YEARS Beat Streuli has lived in Rome, Paris and New York. The metropolis is the natural environment for his photographic work and of it he supplies physiognomical fragments, mainly in black and white. The big city no longer represents a secret, darkness or danger. Nor is it a seething jungle or a labyrinth. Neither is it a counter image of lost nature. This main representative of the civilisation of the western modern era has itself become natural. The life of its inhabitants causes the everyday, the familiar, the ordinary to congeal into a form which is difficult to grasp, is constantly changing and yet still recognisable. Any identification between one city and another is achieved by the details and the rhythm to which they are subject.

Beat Streuli approaches this stream wherever possible via snapshots, which he liberates from the dictates of critical development. Thus we are not presented with decisive moments which sum up situations, narrate a story, describe a social structure, a policy or a disposition. There is no recognisable whole which could be referred to. The extracts remain so much a part of the event from which they were torn that they are drawn back to it as if by suction. Streuli squeezes the figures into the photograph, has us follow lines of vision, blurs swiftly passing bodies, until that which is to be seen demands to be extended above and beyond the edges of the 137 x 201 cm formats or into the next photograph – almost as if the pictures, hung in spatial sequence, were part of a moving film in which the people recede from a close-up into a long-shot and disappear. Streuli's metropolis seems to permit neither narcissistic self-presentation nor any suffering in the faces of the crowd. If anything significant emerges at all from the ordinary then it is only through repetition, small divergences, and comparison.

Whereas the street scenes photographed in Paris were mainly concerned with lettering (on shopping bags, clothing, advertising, signs, car registration plates) and the trelliswork constituted by orthogonal sight barriers and divisive glass reflections, behind which the people were close but unapproachable, in the New York photographs taken over the past three years the main focus of the *flaneur* Streuli's attention is obviously concentrated on the great crowds of people. The constructively fixing gaze resolves itself in a movement which encompasses both the passers-by and the photographer.

GERHARD MACK

Erstveröffentlichung im *Kunstbulletin*, Kriens, Nr. 11/1993.

First published in *Kunstbulletin*, Kriens, No. 11/1993.

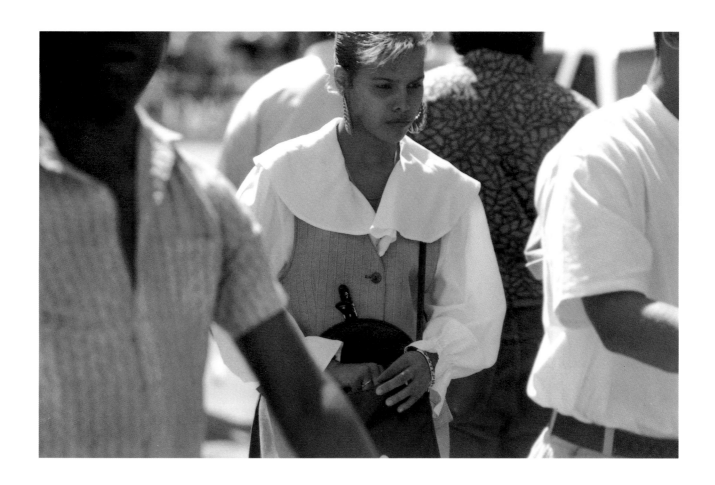

Untitled. From the U.S. Series, 1993–94 (137 x 201 cm)

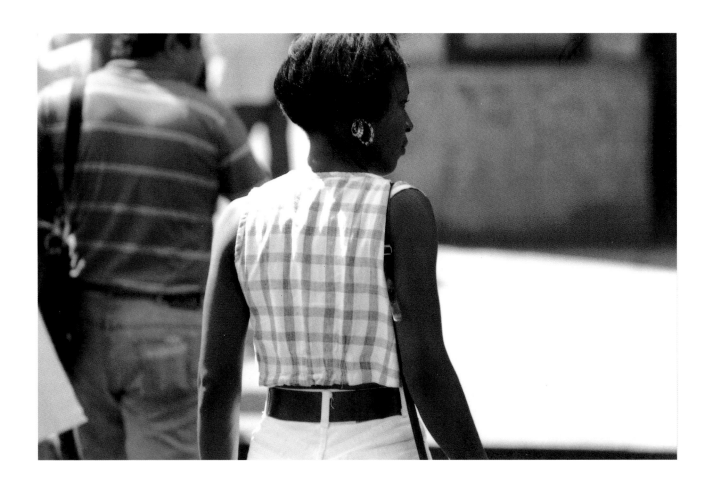

Untitled. From the U.S. Series, 1993–94 (137 x 201 cm)

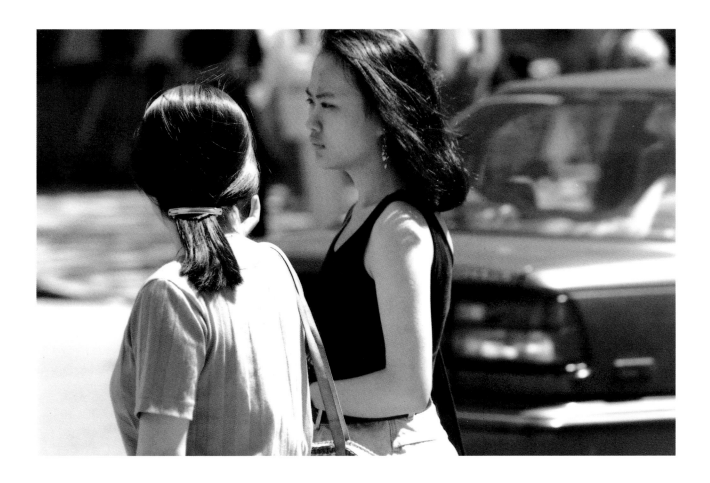

Untitled. From the U.S. Series, 1993–94 (137 x 201 cm)

Thomas Thys

Mich interessiert das Aussehen der alltäglichen Gegenstände im Foto. Ich glaube nicht an Prävisualisierung, an konzeptuelle Regeln und Methoden für meine Arbeit, vielmehr gestatte ich dem fotografischen Prozeß, die als typisch erachteten Merkmale des jeweiligen Gegenstands in Frage zu stellen, sie herauszukehren oder zu verbergen. In der Verfremdung werden die durch Gewohnheit unsichtbar gewordenen Dinge von neuem sichtbar.

Thomas Thys

I am interested in the way everyday objects look when photographed. I am not a believer in previsualization, in conceptual rules and methods for my work; instead I allow the photographic process to question – to augment or hide – those characteristics we feel to be typical of the object. In making things look strange, we bring them back to our visual perception.

Thomas Thys

Lamp Without Light, 1993 (126 x 124 cm)

Pigeon 1, 1993 (128 x 125 cm)

Pigeon II, 1993 (128 x 125 cm)

Marc Viaplana / Mabel Palacín

Die neuen Arbeiten von Marc Viaplana und Mabel Palacín, unter dem Titel *Desapariciónes* ("Verschwinden") zusammengefaßt, variieren das Werk der beiden Künstler in formaler wie konzeptioneller Hinsicht. Ausgehend von der zentralen Idee "What has never been cannot end" vermitteln sie einen neuen Zugang zum Begriff des *Blow-up*, zugleich erschüttern sie die Vorstellungen von Abbildung, Täuschung, Realität, Schein, Zufall, Trugbild. Angesichts einer abgeschossenen Pistolenkugel, die durch den Schuß verformt und zugleich *geformt* wurde, stellt sich uns unvermittelt die Frage nach dem visuellen Verstehen der Dinge, die Frage nämlich, warum die Realität, statt zu *sein*, manchmal nur zu *sein scheint* – ohne damit in eine fruchtlose Diskussion über den Realismus einzutreten. Die abgeschossenen Kugeln verändern ihre Form durch den Aufprall auf einen harten Grund, gleichwohl sind sie weiterhin Kugeln, auch wenn sie ihr gewöhnliches Aussehen verloren haben: Also sind die Dinge irgendwie nur so, wie man sie sieht – eine Auffassung, die, wie Antonioni uns mit *Blow-up* gezeigt hat, auf die Fotografie stärker als auf jedes andere Medium zutrifft.

Manel Clot

Überarbeiteter Auszug aus *Life on Earth 2*, 1993.

The new works by Marc Viaplana and Mabel Palacín, brought together under the title *Desapariciónes* ("Disappearances"), variegate the oeuvre of both artists in a formal as well as a conceptual sense. Proceeding from the central idea "What has never been cannot end", they convey a new approach to the concept of the blow-up, while at the same time upsetting traditional ideas about reproduction, delusion, reality, appearance, chance, and illusion. Seeing a bullet which has been shot from a revolver and thereby simultaneously deformed and *formed*, we are suddenly moved to question our visual understanding of objects: to question why reality, instead of *being*, sometimes only *appears to be* – without entering into a fruitless discussion about realism. The spent bullets have changed their shape through the impact with a hard surface, yet they remain bullets even though they have lost their usual appearance. Somehow, then, objects are only how one sees them – a concept which, as Antonioni showed us in *Blow-up*, applies to photography more than to any other medium.

Manel Clot

Revised excerpt from *Life on Earth 2*, 1993.

Suite de las Desapariciónes (What Has Never Been Cannot End). Movimiento # 5, 1992–93 (320 x 360 cm)

Suite de las Desapariciónes (What Has Never Been Cannot End). Movimiento # 1, 1992–93 (320 x 360 cm)

Suite de las Desapariciónes (What Has Never Been Cannot End). Movimiento # 2, 1992–93 (320 x 300 cm)

129

ANGELA BERGLING

1964 born in Springe, Germany,
lives in Hamburg.

GROUP EXHIBITIONS
1986 "Award for Young European Photographers 1986", Frankfurter Kunstverein, Frankfurt am Main
1992 "Blow Up", BFF Jahreskongreß, Zoo-Gesellschaftshaus, Frankfurt am Main
"Panamericana" (in collaboration with Carsten Witte), photokina, Cologne

SELECTED PUBLICATIONS
Fachblatt für Synapsen, Hamburg, nr. 2, 1992
Country, Hamburg, nr. 2, 1992
Tempo, Hamburg, nr. 1, 1992
Leica Fotografie International, Frankfurt am Main, nr. 2, 1993
Tempo, Hamburg, nr. 6, 1994
Boom, Hamburg, nr. 11, 1994

DIRK BRAECKMAN

1958 born in Eeklo, Belgium,
lives in Ghent.

SELECTED INDIVIDUAL EXHIBITIONS
1986 Galerie Perspektief, Rotterdam
Studio 666, Paris
1990 Contretype, Brussels
1992 L.A. Galerie, Frankfurt am Main
Galerie Réverbère 2, Lyon
1993 Contretype, Brussels
Galerie S.+H. De Buck, Ghent

SELECTED GROUP EXHIBITIONS
1985 "Award for Young European Photographers 1985", Frankfurter Kunstverein, Frankfurt am Main
Journées Internationales de la Photographie, Hôtel de Ville, Montpellier
1990 Mai de la Photo, Reims
"Award for Young European Photographers 1990", Berlinische Galerie/Martin-Gropius-Bau, Berlin
1992 "L'Echappée Européenne", Pavillon des Arts, Paris
1993 "Junge Helden", Museum voor Fotografie, Antwerp

SELECTED PUBLICATIONS
European Photography, Göttingen, nr. 25, 1986
Perspektief, Rotterdam, nr. 22, 1985
PhotoVision, Madrid, nr. 18, 1987
Clichés, Brussels, nr. 43, 1988
Photographies, Paris, nr. 33, 1991
European Photography, Göttingen, nr. 45, 1991
Dirk Braeckman. Ghent: Self-published, 1992
European Photography, Göttingen, nr. 54, 1993

GILLES BUYLE-BODIN

1958 born in Grenoble, France,
lives in Grenoble.

SELECTED INDIVIDUAL EXHIBITIONS
1982 L'Olympic Entrepôt, Paris
1986 Galerie 43, Paris
1987 Galerie Perrain, Paris
1993 Galerie Zig-Zag, Grenoble
1994 Galerie Snapshot, Amiens

GROUP EXHIBITIONS
1982 American Center, Paris
1985 Studio de l'Arc, Arles
"Award for Young European Photographers 1985", Frankfurter Kunstverein, Frankfurt am Main
1986 Studio 666, Paris

PUBLICATIONS
European Photography, Göttingen, nr. 25, 1986
Art Press, Paris, nr. 120, 1987
Clichés, Brussels, nr. 35, 1987
Gilles Buyle-Bodin: La Face du Vampire. Paris: Carnets Argraphie, 1987
European Photography, Göttingen, nr. 40, 1989

HERVÉ CHARLES

1965 born in Nivelles, Belgium,
lives in Obaix.

SELECTED INDIVIDUAL EXHIBITIONS
1991 L.A. Galerie, Frankfurt am Main
 Le Printemps Amandinois de la
 Photographie, Saint-Amand-les-Eaux
1992 Galerie Détour, Namur
1994 Galerie Damasquine, Brussels
 L.A. Galerie, Frankfurt am Main

SELECTED GROUP EXHIBITIONS
1989 Mai de la Photo, Reims
1990 "Award for Young European Photog-
 raphers 1990", Berlinische Galerie/
 Martin-Gropius-Bau, Berlin
1991 "La Photographie Belge", Centre
 National de la Photographie/Palais de
 Tokyo, Paris
1992 Zomer van de fotografie, Antwerp
1993 "Pour une Histoire de la Photographie
 en Belgique", Musée de la Photogra-
 phie, Charleroi

SELECTED PUBLICATIONS
European Photography, Göttingen, nr. 45, 1991
Mai de la Photo. Reims: Priorité Ouverture,
1992
Histoire de la Photographie en Belgique.
Charleroi: Musée de la Photographie, 1993
Transfigurations. Charleroi: Musée de la
Photographie, 1994

HANNAH COLLINS

1956 born in London, England,
lives in Barcelona.

SELECTED INDIVIDUAL EXHIBITIONS
1989 Walker Art Center, Minneapolis
 Galerie Xavier Hufkens, Brussels
1990 Galerie Tanit, Cologne
1991 Paley Wright Gallery, London
 S.L. Simpson Gallery, Toronto
1992 Galeria Joan Prats, Barcelona
 The Power Plant, Toronto
1993 Tate Gallery, London
 Center for Contemporary Art, Warsaw
1994 Leo Castelli Gallery, New York

SELECTED GROUP EXHIBITIONS
1988 Australian Biennale, Art Gallery of
 New South Wales, Sydney
1989 "L'Invention d'un Art", Centre
 Georges Pompidou, Paris
1990 "Images in Transition", National
 Musum of Modern Art, Kyoto
1991 "European Photography Award 1991",
 Künstlerwerkstatt im Bahnhof West-
 end, Berlin
1992 "In Vitro", Fundació Miró, Barcelona
1993 "Salon de Los 16", Palacio Velazquez,
 Madrid
1994 "Image/Image", Museum of Contem-
 porary Art, Ghent

SELECTED PUBLICATIONS
Artscribe, London, nr. 64, 1987
De Appel Magazine, Amsterdam, nr. 2, 1988
Hannah Collins: Legends. London: Institute
of Contemporary Arts/Matt's Gallery, 1988
Hannah Collins: Viewpoints Series. Minnea-
polis: Walker Art Center, 1989
Camera Austria, Graz, nr. 29, 1991
European Photography, Göttingen, nr. 49,
1992
Hannah Collins. Barcelona: Generalitat de
Catalunya, 1993

MARINA COX

1960 born in Cefalù, Italy,
lives in Brussels.

SELECTED INDIVIDUAL EXHIBITIONS
1988 Galerie Junod, Lausanne
1991 Galerie Agathe Gaillard, Paris
1993 Conseil de l'Europe, Strasbourg
1994 Musée de la Photographie, Charleroi
 Sarajevska Zima, Sarajevo

SELECTED GROUP EXHIBITIONS
1987 "Award for Young European Photog-
 raphers 1987", Frankfurter Kunst-
 verein, Frankfurt am Main
1988 "Questioning Europe – Reinterpreta-
 tions within Photography", Fotografie
 Biënnale, Rotterdam
 "Contemporary Belgian Photography",
 Marcuse Pfeifer Gallery, New York
1991 "Des Vessies et des Lanternes –
 Curiosités Photographiques", Centre
 Cultural Le Botanique, Brussels
1993 "Culturele Prijzen 1992 – Provincie
 Antwerpen", Provinciezaal, Antwerp
1994 Festival de Louvain-la-Neuve, Halles
 Universitaires, Louvain-la-Neuve

SELECTED PUBLICATIONS
Clichés, Brussels, nr. 40, 1987
European Photography, Göttingen, nr. 33, 1988
Focus, Amsterdam, nr. 1, 1988
Izbjeglica – Les bafoués de l'ex-Yougoslavie.
Brussels: Editions Causes Communes, 1993

Lenni van Dinther

1953 born in Valkenswaard, Netherlands, lives in Aigaliers, France.

Selected individual exhibitions
1986 Studio 666, Paris
1989 Le Carrefour des Arts, Marseille
1990 Espace Saint-Cyprien, Toulouse
1991 Galerie Suzel Berna, Antibes
Artothèque Sud, Nimes
1993 Théatre des Treize Vents, Montpellier
ARPAC, Fondation de Pioch Pelat,
Montpellier

Selected group exhibitions
1987 "Rapports – Contemporary Photography from France", The Photographers' Gallery, London
1988 "Splendeurs et Misères du Corps", Musée d'Art Moderne de la Ville de Paris
1990 "Award for Young European Photographers 1990", Berlinische Galerie/ Martin-Gropius-Bau, Berlin
1991 "La Photographie Française en Liberté", International Center of Photography, New York
1992 "Bestiaire Photographique", Provinciehuis, Zwolle
1993 Selest'Art, Biennale d'Art Contemporain, Selesta

Selected publications
Beaux Arts Magazine, Paris, nr. 52, 1987
La Recherche photographique, Paris, nr. 4, 1988
European Photography, Göttingen, nr. 45, 1991
Artension, Paris, nr. 29, 1991

Henrik Duncker

1963 born in Helsinki, Finland, lives in Helsinki.

Selected individual exhibitions
1991 Kirjakahvila Into, Tampere
1993 Museum of Applied Arts, Helsinki
Vihti Museum, Vihti
Fotografiska Museet, Stockholm
1994 Galleri Zebra, Karjaa

Selected group exhibitions
1990 "Photonkhamon", Finnfoto Gallery, Helsinki
1991 "Intiankatu 20", touring exhibition, Helsinki
1993 "European Photography Award 1993", Kulturzentrum Englische Kirche, Bad Homburg
Mesiac Fotografie, Bratislava
1994 "Hay on the Highway", Lönnström Art Museum, Rauma

Selected publications
Valokuva, Helsinki, nr. 3, 1991
Henrik Duncker/Yrjö Tuunanen: Hay on the Highway. Helsinki: Self-published, 1993
Valokuva, Helsinki, nr. 4, 1993
European Photography Award 1993. Göttingen: European Photography, 1993
Taide, Helsinki, nr. 1, 1994

Dörte Eissfeldt

1950 born in Hamburg, Germany, lives in Hamburg.

Selected individual exhibitions
1982 Museum Folkwang, Essen
1986 PPS-Galerie, Hamburg
1987 Kunstverein Karlsruhe
1988 Kunstverein Hamburg
1989 Galerie Fotohof, Salzburg
1990 Kunst-Station Sankt Peter, Cologne
1992 Les Ateliers Nadar, Marseille
Fotoraum Fleetinsel/Galerie Elke Dröscher, Hamburg
1994 Museum für Kunst und Gewerbe, Hamburg

Selected group exhibitions
1985 "Award for Young European Photographers 1985", Frankfurter Kunstverein, Frankfurt am Main
1986 "Reste des Authentischen – Fotobilder der 80er Jahre", Museum Folkwang, Essen
1988 "Fotovision", Sprengel Museum, Hanover
1989 "L'Invention d'un Art", Centre Georges Pompidou, Paris
1991 "Zehn Jahre Deutscher Kunstfonds", Kunstverein Bonn
1993 "Kunstfotografie der 90er Jahre", Architekturmuseum, Frankfurt am Main

Selected publications
Fotografie, Göttingen, nr. 30/31, 1984
European Photography, Göttingen, nr. 25, 1986
Dörte Eißfeldt: Schneeball. Göttingen: European Photography, 1990
Perspektiven – Fotografinnen in Deutschland und Japan. Kawasaki: City Museum, 1990
Hamburger Fotografinnen. Heidelberg: Edition Braus, 1991
Dörte Eißfeldt: POL. München: Nazraeli Press, 1992

Touhami Ennadre

1953 born in Casablanca, Morocco,
lives in Paris.

Selected individual exhibitions
1985 Maison de la Culture, Grenoble
1986 Galerie Michèle Chomette, Paris
1987 Galerie l'Atelier, Rabat
1990 Institut du Monde Arabe, Paris
1994 Exit Art, New York

Selected group exhibitions
1978 "La jeune photographie en France
aujourd'hui", Musée d'Art Moderne de
la Ville de Paris
1987 "Award for Young European Photog-
raphers 1987", Frankfurter Kunst-
verein, Frankfurt am Main
1988 "Splendeurs et Misères du Corps",
Musée d'Art Moderne de la Ville de
Paris
1992 "In Vitro", Fundació Miró, Barcelona

Selected publications
Camera International, Paris, nr. 3, 1985
European Photography, Göttingen, nr. 33, 1988
The Sun, Tokyo, nr. 335, 1991
Notre-Dame de Paris. Paris: Caisse des
Monuments Historiques et des Sites, 1992
Déjà-vu, Tokyo, nr. 12, 1993

Thomas Florschuetz

1957 born in Zwickau, Germany,
lives in Berlin and Paris.

Selected individual exhibitions
1987 Museum Folkwang, Essen
1988 Anderson Gallery, Richmond
1989 PPS-Galerie, Hamburg
1990 Galerie du Jour, Paris
1992 Galerie Vier, Berlin
Galerie Nikolaus Sonne, Berlin
1994 Neuer Berliner Kunstverein, Berlin

Selected group exhibitions
1987 "Award for Young European Photog-
raphers 1987", Frankfurter Kunst-
verein, Frankfurt am Main
1989 "Das Medium der Fotografie ist be
rechtigt, Denkanstöße zu geben",
Hamburger Kunstverein, Hamburg
"New Photography V", Museum of
Modern Art, New York
1992 "INTERFACE", Corcoran Gallery of
Art, Washington
1993 "Das Bild des Körpers", Frankfurter
Kunstverein, Frankfurt am Main
"Elective Affinities", Tate Gallery,
Liverpool
1994 "Dorothea-von-Stetten-Kunstpreis
1994", Kunstmuseum Bonn

Selected publications
European Photography, Göttingen, nr. 32, 1987
Thomas Florschuetz. Richmond: Anderson
Gallery, 1988
Total Inconnu. Paris: Galerie du Jour, 1992
Sprung in die Zeit. Berlin: Ars Nicolai, 1992
Peter Weiermair (Hg.): Das Bild des Körpers.
Schaffhausen: Edition Stemmle, 1993

Anna Fox

1961 born in Alton, England,
lives in London.

Selected individual exhibitions
1986 Central Studio, Basingstoke
1988 Camerawork, London
1990 The Photographers' Gallery, London
1991 Galerie Le Lieu, Lorient
1993 Galeria Spectrum, Zaragoza
The Edge Gallery, London
1994 Braga Festival of Photography, Braga
Vigo Festival of Photography, Vigo

Selected group exhibitions
1989 "Through the Looking Glass",
Barbican Art Gallery, London
1991 "Regeneration III", The Mappin
Gallery, Sheffield
1992 "ICI Fox Talbot Awards", National
Portrait Gallery, London
Primavera Fotogràfica, British Insti-
tute, Barcelona
1993 "Documentary Dilemmas", Mês Inter-
nacional da Fotografia, São Paulo
"European Photography Award 1993",
Kulturzentrum Englische Kirche, Bad
Homburg
1994 "Warworks", Fotografie Biënnale,
Rotterdam
"Documentary Dilemmas", Gallery of
Photography, Dublin

Selected publications
Creative Camera, London, nr. 11, 1986
Workstations. London: Camerawork, 1988
Camera Austria, Graz, nr. 27, 1988
Aperture, New York, nr. 113, 1989
La Recherche photographique, Paris, nr. 13,
1992
The Guardian Weekend, 13/14 November 1993

KIUSTON HALLÉ

1952 born in Paris, France,
lives in Paris.

SELECTED INDIVIDUAL EXHIBITIONS
1985 Galerie Samia Saouma, Paris
1986 Pace/MacGill Gallery, New York
1987 Bibliothèque Nationale, Paris
1990 Musée des Beaux-Arts, Rennes
1991 Espace Saint-Cyprien, Toulouse
1992 Le Parvis, Tarbes
 Jane Corkin Gallery, Toronto

SELECTED GROUP EXHIBITIONS
1979 "Paysages", Bibliothèque Nationale,
 Paris
1980 "Instantanés", Centre Georges
 Pompidou, Paris
1983 "Trois femmes photographes",
 Fondation Nationale de la Photo-
 graphie, Lyon
1986 "Award for Young European Photog-
 raphers 1986", Frankfurter Kunst-
 verein, Frankfurt am Main
1989 "20 ans de photographie créative en
 France", Museum Ludwig, Cologne

SELECTED PUBLICATIONS
Photo Reporter, Paris, nr. 10, 1979
Photographies, Paris, nr. 6, 1981
Art Press, Paris, nr. 69, 1983
Camera International, Paris, nr. 2, 1984
European Photography, Göttingen, nr. 29,
1987
La Recherche photographique, Paris, nr. 4, 1988
Petra Olschewski (Hg.): Frauenbilder. Schaff-
hausen: Edition Stemmle, 1987

BERND HOFF

1959 born in Westerstaede, Germany,
lives in Essen.

GROUP EXHIBITIONS
1986 "Award for Young European Photog-
 raphers 1986", Frankfurter Kunst-
 verein, Frankfurt am Main
1986 "Altena", Kunsthaus Altena
1987 "Einmenschwelt", Galerie Lichtblick,
 Cologne

SELECTED PUBLICATIONS
European Photography, Göttingen, nr. 29,
1987
Stern, Hamburg, nr. 10, 1989
Tempo, Hamburg, nr. 3, 1990
Stern, Hamburg, nr. 11, 1990
Greenpeace Magazin, Hamburg, nr. 1–4, 1990

HENRY LEWIS

1957 born in Sydney, Australia,
lives in Tarascon, France.

SELECTED INDIVIDUAL EXHIBITIONS
1981 Galerie Texbraun, Paris
1985 Josef Albers Museum, Bottrop
1987 Centre de la Vieille Charité, Marseille
1989 Galerie Baudoin Lebon, Paris
1990 Centre d'Art Contemporain, Troyes

SELECTED GROUP EXHIBITIONS
1985 "Das Selbstporträt im Zeitalter der
 Photographie", Württembergischer
 Kunstverein, Stuttgart
1988 "Award for Young European Photog-
 raphers 1988", Museum Ludwig,
 Cologne
1990 "L'Estaque, une commande publique",
 Centre de la Vieille Charité, Marseille

SELECTED PUBLICATIONS
Henry Lewis: LVNA PROXIMA. Marseille:
Centre de la Vieille Charité, 1987
Lewis-Thomas: Radiographie. Troyes: Centre
d'Art Contemporain, 1990–91
PhotoVision, Barcelona, nr. 22, 1991
Lewis-Thomas: Image Primordial. Barcelona:
Centre d'Art Santa Mònica, 1990
European Photography, Göttingen, nr. 41,
1990

Christianne Thomas is a French painter
whose work is associated with minimalism.
She met Henry Lewis in San Francisco and
they have worked together using the name
Lewis–Thomas.

Leif Lindberg

1959 born in Hammarö, Sweden,
lives in Oslo.

Individual exhibitions
1991 Galleri Irving, Malmö
 Gallery Index, Stockholm
 Härnösands Konsthall, Härnösand
1992 Galleri Finnfoto, Helsinki
1994 Galleri Heer, Oslo

Group exhibitions
1990 "Some Swedish Strategies", Gallery
 Kinni, Tallinn (touring the Baltic
 States)
 "The Machine of Sight", House of
 Culture, Charkov (touring the Baltic
 States)
1991 "European Photography Award 1991",
 Künstlerwerkstatt im Bahnhof West-
 end, Berlin
 "Equal to", Moderna Museet,
 Stockholm
 "New Spaces of Photography",
 Museum of Architecture, Wroclaw
1993 Fotofeis – Scottish International
 Festival of Photography, Edinburgh
1994 "Stranger than Paradise – Contempo-
 rary Scandinavian Photography",
 International Center of Photography,
 New York

Publications
The Swedish Model. Stockholm: Self-pub-
lished, 1990
Across Europe. Sunderland: AN Publications,
1992
Creative Camera, London, nr. 312, 1992
F-15 Kontakt, Moss, June 1993
Katalog, Odense, nr. 4, 1993
Hyperfoto, Oslo, nr. 1, 1994

Martí Llorens

1962 born in Barcelona, Spain,
lives in Barcelona.

Selected individual exhibitions
1989 Galeria Contraluz, Barcelona
1990 Art Gallery of the Cankarjev Dom/
 Cultural Center, Ljubljana
1992 Galerie Bodo Niemann, Berlin

Selected group exhibitions
1988 "La Camara Ciega", Museo de Arte
 Contemporáneo, Sevilla
 "Photographie Contemporaine Espag
 nole", Musée Cantini, Marseille
1989 "Espai de Temps", Sala Arcs, Barcelona
1990 "Regards sur la Photographie Cata
 lane", Théâtre de l'Agora, Evry
1991 "The Fourth Wall. Photography as
 Theatre", De Oude Kerk, Amsterdam
 "European Photography Award 1991",
 Künstlerwerkstatt im Bahnhof West-
 end, Berlin
1992 "De la Fotografía Española", Instituto
 de Cooperación Iberoamericana, Bue-
 nos Aires

Selected publications
*Pere Formiguera/Toni Cumelle (eds.): Porta
d'Aigua.* Barcelona: Lunwerg Editores, 1989
European Photography, Göttingen, nr. 35, 1988
FV/Foto-Video Actualidad, Madrid, nr. 10,
1989
FV/Foto-Video Actualidad, Madrid, nr. 19,
1990
Artes & Leiloes, Lisbon, nr. 3, 1990
European Photography Award 1991. Göttingen:
European Photography, 1991
Photographies Magazine, Paris, nr. 43, 1992

Frédéric Marsal

1956 born in Saint Etienne, France,
lives in Paris.

Individual exhibitions
1988 La Librairie Bleue, Paris
1991 Galerie Pons, Paris
1992 Fountainhead Gallery, Houston
 Musée de la Photographie, Charleroi

Group exhibitions
1988 "Tremplin pour des Images", Centre
 National de la Photographie, Paris
 "Fond National d'Art Contemporain",
 Centre National de la Photographie,
 Paris
1989 "Award for Young European Photog-
 raphers 1989", Frankfurter Kunst-
 verein, Frankfurt am Main
1990 Espace Sussuta Boe, Brussels
1991 Galerie Pons, Paris
1992 Musée du Botanique, Brussels
 "Photographes Européens", Rencontres
 d'Arles
1994 "Sans domicile fixe", Artothèque,
 Nantes

Publications
Clichés, Brussels, nr. 62, 1990
Camera International, Paris, nr. 12, 1991
La Recherche photographique, Paris, nr. 14,
1993

ERWIN OLAF

1959 born in Hilversum, Netherlands,
lives in Amsterdam.

SELECTED INDIVIDUAL EXHIBITIONS
1987 Anderes Ufer, Berlin
1988 Focus Galerie, Amsterdam
1990 Museum Fodor, Amsterdam
1993 AB Galerie, Paris
 Kunsthal, Rotterdam

SELECTED GROUP EXHIBITIONS
1984 Foto '84, Nieuwe Kerk, Amsterdam
1986 "Männer sehen Männer", Frankfurter
 Kunstverein, Frankfurt am Main
1988 "Award for Young European Photog-
 raphers 1988", Museum Ludwig,
 Cologne
 La Bienal de Barcelona, Centro de
 Cultura Contemporania, Barcelona
1992 "Illusions et Travestissements", AB
 Galerie, Paris

SELECTED PUBLICATIONS
Erwin Olaf: Stadsgezichten. Amsterdam: De
Woelrat, 1985
*Erwin Olaf: Chessmen. An Attempt to Play the
Game.* Harleem: Focus Uitgeverij, 1988
Erwin Olaf: Joy. Harleem: Focus Uitgeverij,
1993

MABEL PALACÍN

1964 born in Barcelona, Spain,
lives in Barcelona.

SELECTED INDIVIDUAL EXHIBITIONS
1988 Sala de Exposiciones de la Fundació
 Caixa de Pensions, Barcelona
1990 Galeria Alfonso Alcolea, Barcelona
 L.A. Galerie, Frankfurt am Main
1992 Galerie Bouqueret+Lebon, Paris
1993 L.A. Galerie, Frankfurt am Main
 Centre Culturel de l'Albigeois, Albi

SELECTED GROUP EXHIBITIONS
1989 "Award for Young European Photog-
 raphers 1989", Frankfurter Kunst-
 verein, Frankfurt am Main
1991 "Historias de Amor. Fragmentos de un
 discurso artístico", Ateneo Mercantil,
 Valencia
1992 "Historia natural. El doble hermético",
 CAAM, Las Palmas de Gran Canaria
1993 "Trasbals – espais de la memòria, es-
 pais de la ment", Museu de Granollers,
 Barcelona
1994 "Los Universos Lúcidos", ARCO 94,
 Madrid
 "Años 90. Distancia cero", Centre
 d'Art Santa Mònica, Barcelona

SELECTED PUBLICATIONS
European Photography, Göttingen, nr. 33, 1988
Snapshots, Part I. Barcelona: Fundació Caixa
de Pensions, 1988
Clichés, Brussels, nr. 52, 1988
European Photography, Göttingen, nr. 41,
1990
Mabel Palacín/Marc Viaplana. Barcelona:
Galería Alfonso Alcolea, 1990
Historia natural. El doble hermético. Las Pal-
mas de Gran Canaria: CAAM, 1992

MARTIN PARR

1952 born in London, England,
lives in Clifton.

SELECTED INDIVIDUAL EXHIBITIONS
1981 Camerawork, London
1982 The Photographers' Gallery, London
1986 The Serpentine Gallery, London
1989 The Royal Photographic Society, Bath
1992 Janet Borden Gallery, New York
1993 Galerie du Jour, Paris
 Watershed Gallery, Bristol

SELECTED GROUP EXHIBITIONS
1972 "Butlins by the Sea", Impressions
 Gallery, York
1985 "Award for Young European Photog-
 raphers 1985", Frankfurter Kunst-
 verein, Frankfurt am Main
1986 "British Contemporary Photography",
 Houston FotoFest, Houston
1989 "Through the Looking Glass – British
 Photography 1945–1989", Barbican
 Centre, London
1991 "British Photography from the
 Thatcher Years", Museum of Modern
 Art, New York
1993 "Photographs from the Real World",
 Lillehammer Art Museum, Lille-
 hammer

SELECTED PUBLICATIONS
Martin Parr: Bad Weather. London:
A. Zwemmers Ltd., 1982
Martin Parr: A Fair Day. Wallasey: Prome-
nade Press, 1984
Martin Parr: The Last Resort. Wallasey: Prom-
enade Press, 1986
Martin Parr: The Cost of Living. Manchester:
Cornerhouse Publications, 1989
Martin Parr: Signs of the Times. Manchester:
Cornerhouse Publications, 1992
Martin Parr: Bored Couples. Paris: Galerie du
Jour, 1993

Jens Rötzsch

1959 born in Leipzig, Germany,
lives in Berlin.

Individual exhibitions
1985 Kreiskulturhaus Treptow, Berlin
1988 Galerie Eigen+Art, Leipzig
1989 Galerie am Steinweg, Suhl
 Camerawork, London
1992 Galerie Zeger Reijers, Rotterdam
 Brandenburgische Kunstsammlungen,
 Cottbus

Selected group exhibitions
1988 X. Kunstausstellung der DDR,
 Dresden
 "Award for Young European Photog-
 raphers 1988", Museum Ludwig,
 Cologne
1990 "Photography in the GDR", National
 Museum of Photography, Film & TV,
 Bradford
 "Das Schöne ist der Glanz des Wahren
 – Tendenzen in der DDR-Fotografie
 der 8oer Jahre", Staatliche Galerie Mo-
 ritzburg, Halle
1992 "NovemberBilder", Brandenburgische
 Kunstsammlungen, Cottbus

Selected publications
F.C. Gundlach (Hg.): Zwischenzeiten – Bilder
ostdeutscher Photographen 1987–1991. Düssel-
dorf: Richter-Verlag, 1991
Zeitbilder – Wegbereiter der Fotografie in der
DDR. Cottbus: Staatliche Kunstsammlungen,
1990
Reinhild Tetzlaff/Ullrich Wallenburg (Hg.):
NovemberBilder. Cottbus: Staatliche Kunst-
sammlungen, 1992
Jens Rötzsch: Zeitläufe. Farbfotografien 1987–
1992. Cottbus: Brandenburgische Kunst-
sammlungen, 1993
Aufbruch nach Deutschland. Berlin: Ostkreuz/
Agentur der Fotografen, 1993

Eva Schlegel

1960 born in Hall, Austria,
lives in Vienna.

Selected individual exhibitions
1989 Galerie Krinzinger, Vienna
1990 Shoshana Wayne Gallery, Los Angeles
1991 Galerie Cora Hölzl, Düsseldorf
1993 Galerie Krinzinger, Vienna
1994 Shoshana Wayne Gallery, Los Angeles
 Galerie Klaus Fischer, Berlin

Selected group exhibitions
1988 "Ein anderes Klima", Kunsthalle für
 die Rheinlande und Westfalen,
 Düsseldorf
1991 "Cadences", The New Museum of
 Contemporary Art, New York
1992 "Interferenzen VI", Museum Moder-
 ner Kunst/Palais Lichtenstein, Vienna
 "European Photography Award 1992",
 Künstlerwerkstatt im Bahnhof West
 end, Berlin
1993 "Prospect 93", Frankfurter Kunst-
 verein, Frankfurt am Main

Selected publications
Kunstforum, Cologne, nr. 91, 1989
Flash Art, London, nr. 150, 1990
Noema Art Magazine, Salzburg, nr. 6, 1990
Artis, Zürich, nr. 1, 1990
Eikon, Vienna, nr. 4, 1992

Erasmus Schröter

1956 born in Leipzig, Germany,
lives in Hamburg.

Selected individual exhibitions
1984 Centre Culturel, Poitiers
1990 Maison de la Roquette, Arles
1991 PPS-Galerie, Hamburg
1992 Galerie Perspektief, Rotterdam
1993 Fotogalerie Wien, Vienna
 Hippolyte Galleri, Helsinki
1994 Imkabinett Galerie, Berlin

Group exhibitions
1989 "Stipendiatenausstellung", Museum
 Folkwang, Essen
1992 "European Photography Award 1992",
 Künstlerwerkstatt im Bahnhof West
 end, Berlin
1993 "Europese Oefeningen", Galerie DB-S,
 Antwerp
1994 Museo Ken Damy, Brescia

Selected publications
The Manipulator, Düsseldorf, nr. 15, 1988
Aperture, New York, nr. 123, 1991
Perspektief, Rotterdam, nr. 44, 1992
La Recherche photographique, Paris, nr. 13,
1992
Neue Bildende Kunst, Berlin, nr. 2, 1994
ZEITmagazin, Hamburg, nr. 23, 1994

Mikołaj Smoczynski

1955 born in Lodz, Poland,
lives in Lublin.

Selected individual exhibitions
1986 Foto Medium Art, Wroclaw
1988 Galerie l'Ollave
1990 Foksal Gallery, Warsaw
1991 San Francisco State University Art
 Gallery, San Diego
 Wschodnia Gallery, Lodz
1992 Stara Gallery, Lublin
1993 Center for Contemporary Art, Warsaw
 Rosa Esman Gallery, New York

Selected group exhibitions
1985 "Contemporary Art from Poland",
 Walter Philips Gallery, Banff, Canada
 "Award for Young European Photog-
 raphers 1985", Frankfurter Kunst-
 verein, Frankfurt am Main
1989 "Supplements", John Hansard Gallery,
 Southampton
1990 "Construction in Process", Tapestry
 Museum, Lódz
1992 "Lódz – Lyon", Elac/Musée d'Art
 Contemporain, Lyon

Selected publications
Project, Warsaw, nr. 173, 1987
Fotografia, Warsaw, nr. 43, 1987
Art Monthly, London, nr. 122, 1988/89
Mikołaj Smoczynski: Secret Performances.
New York: Performance Project Inc., 1990
6x9, Warsaw, nr. 5, 1991
Art Press, Paris, nr. 168, 1992
European Photography Award 1992.
Göttingen: European Photography, 1992
Art in America, New York, nr. 2, 1994

Beat Streuli

1957 born in Altdorf, Switzerland,
lives in Düsseldorf and New York.

Selected individual exhibitions
1990 Helmhaus, Zürich
1992 Galerie Anne de Villepoix, Paris
 Galerie Conrads, Düsseldorf
 Galerie Walcheturm, Zürich
1993 Kunstmuseum Luzern
1994 Galerie Daniel Buchholz, Cologne
 Galerie Conrads, Düsseldorf
 Galerie Carine Campo, Antwerp
 Galerie Monica de Cardenas, Milan
 Galerie Vera van Laer, Knokke

Selected group exhibitions
1991 "Artistes de la Collection", Fondation
 Cartier, Jouy-en-Josas
 "Lieux communs, Figures singulières",
 Musée d'Art Moderne de la Ville de
 Paris
1992 "Another Subjectivity", Galerie Mar-
 tina Detterer, Frankfurt am Main
1993 "Verwandtschaften", Kunsthal
 Rotterdam
 "New Photography", Museum of
 Modern Art, New York
 "European Photography Award 1993",
 Kulturzentrum Englische Kirche, Bad
 Homburg
1994 "The Act of Seeing", Fondation pour
 l'Architecture, Brussels
 "Et passim", Kunsthalle Bern
 "Soggetto-Soggetto", Castello di Rivoli

Selected publications
Du, Zürich, nr. 8, 1985
Das Kunstwerk, Stuttgart, September 1986
Beat Christoph Streuli: Fotografien Rom 1989/I.
Rome: Istituto Svizzero di Roma, 1989
Beat Christoph Streuli: Rom Paris Fotografien.
Baden: Verlag Lars Müller, 1990
Parkett, Zürich, nr. 25, 1990
Galeries Magazine, Paris, nr. 57, 1993/94

Thomas Thys

1966 born in Ekeren, Belgium,
lives in Antwerp.

Selected group exhibitions
1988 Fabrik '88, Antwerp
1989 "Award for Young European Photog-
 raphers 1989", Frankfurter Kunst-
 verein, Frankfurt am Main
1990 "Provinciale Prijs voor Fotografie",
 Museum voor Fotografie, Antwerp
1992 Part Bleu Galerie, Antwerp
1993 "Pour une Histoire de la Photographie
 en Belgique depuis 1839", Musée de la
 Photographie, Charleroi
 Galerie Fotomania, Rotterdam

Selected publications
European Photography, Göttingen, nr. 41,
1990
*The Other Side of Photography – Profiles of
Education '89.* Amsterdam: De Balie/Gerrit
Rietveld Academie, 1989
*Pour une Histoire de la Photographie en
Belgique depuis 1839.* Charleroi: Musée de la
Photographie, 1993

Yrjö Tuunanen

1964 born in Kauhava, Finland,
lives in Helsinki.

SELECTED INDIVIDUAL EXHIBITIONS
1992 "If Lada Were a Car" (documentary
 film in collaboration with Lasse
 Saarinen), Tampere Film Festival
1993 Museum of Applied Arts, Helsinki
 Vihti Museum, Vihti
 Fotografisca Museet, Stockholm
1994 Galleri Zebra, Karjaa

SELECTED GROUP EXHIBITIONS
1991 "Wo!men at Work", touring exhibi-
 tion, Helsinki
1993 "European Photography Award 1993",
 Kulturzentrum Englische Kirche, Bad
 Homburg
 Mesiac Fotografie, Bratislava
1994 "Hay on the Highway", Lönnström
 Art Museum, Rauma

SELECTED PUBLICATIONS
*Henrik Duncker/Yrjö Tuunanen: Hay on the
Highway.* Helsinki: Self-published, 1993
Valokuva, Helsinki, nr. 4, 1993
Index, Stockholm, nr. 4, 1993
European Photography Award 1993. Göttingen:
European Photography, 1993
Taide, Helsinki, nr. 1, 1994

Marc Viaplana

1962 born in Barcelona, Spain,
lives in Barcelona.

SELECTED INDIVIDUAL EXHIBITIONS
1988 Sala de Exposiciones de la Fundació
 Caixa de Pensions, Barcelona
1990 Galería Alfonso Alcolea, Barcelona
 L.A. Galerie, Frankfurt am Main
1992 Galerie Bouqueret+Lebon, Paris
1993 L.A. Galerie, Frankfurt am Main
 Centre Culturel de l'Albigeois, Albi

SELECTED GROUP EXHIBITIONS
1989 "Award for Young European Photog-
 raphers 1989", Frankfurter Kunst-
 verein, Frankfurt am Main
1991 "Historias de Amor. Fragmentos de un
 discurso artístico", Ateneo Mercantil,
 Valencia
1992 "Historia natural. El doble hermético",
 CAAM, Las Palmas de Gran Canaria
1993 "Trasbals – espais de la memòria, es
 pais de la ment", Museu de Granollers,
 Barcelona
1994 "Los Universos Lúcidos", ARCO 94,
 Madrid
 "Años 90. Distancia cero", Centre
 d'Art Santa Mònica, Barcelona

SELECTED PUBLICATIONS
European Photography, Göttingen, nr. 33, 1988
Snapshots, Part I. Barcelona: Fundació Caixa
de Pensions, 1988
Clichés, Brussels, nr. 52, 1988
European Photography, Göttingen, nr. 41,
1990
Mabel Palacín/Marc Viaplana. Barcelona:
Galería Alfonso Alcolea, 1990
Historia natural. El doble hermético. Las Pal-
mas de Gran Canaria: CAAM, 1992

Chronology

Deutsche Leasing AG's active promotion of the arts boasts a tradition that goes back more than twenty years. The company began sponsoring annual graphics competitions at German art academies in 1974, and in 1982 organised its first competition for art photography. Three years later the promotional concept was fundamentally broadened when entries were invited for the first "Award for Young European Photographers": the prize money was increased, photographers from all over Europe became eligible, an international jury of experts was appointed, and the prize-winning works were presented to a wider public through exhibitions and publications. The aim of the new prize was to promote experimental and innovative work in the medium of photography, irrespective of theme, style, or technique. When in 1990 the number of entrants increased to almost 1,300 and the quantitative dimension of the competition threatened to detract from its aim, the competition was reorganised on the basis of a curator model and given the now-established name "European Photography Award". Since 1991 ten jurors from different European countries have each nominated three artists, and met in a joint session to select the prize-winners.

1985

Entries
714 participants from 22 countries submitting 3,750 works

Jury
Elisabeth Dietz, art collector, Frankfurt am Main
Jean-Claude Lemagny, curator, Bibliothèque Nationale, Paris
Daniela Mrázková, editor, *Fotografie*, Prague
Andreas Müller-Pohle, photographer and publisher, *European Photography,* Göttingen
Bas Vroege, editor, *Perspektief*, Rotterdam
Peter Weiermair, director, Frankfurter Kunstverein, Frankfurt am Main

Prizewinners
1st Prize: Dörte Eißfeldt, Hamburg
2nd Prize: Gilles Buyle-Bodin, Grenoble
3rd Prize: Martin Parr, Wallasey

Exhibition
Frankfurter Kunstverein, Frankfurt am Main

Publication
"Young European Photographers '85", *European Photography*, Göttingen, nr. 25, 1986

1986

Entries
914 participants from 26 countries submitting 4,161 works

Jury
Jean-François Chevrier, critic and curator, Paris
Sue Davies, director, The Photographers' Gallery, London
Elisabeth Dietz, art collector, Frankfurt am Main
Andreas Müller-Pohle, photographer and publisher, *European Photography,* Göttingen
Jerzy Olek, photographer and gallerist, Foto-Medium-Art, Wroclaw
Peter Weiermair, director, Frankfurter Kunstverein, Frankfurt am Main

Prizewinners
1st Prize: Bernd Hoff, Essen
2nd Prize: Angela Bergling, Springe
3rd Prize: Kiuston Hallé, Paris

Exhibition
Frankfurter Kunstverein, Frankfurt am Main

Publication
"Young European Photographers '86", *European Photography*, Göttingen, nr. 29, 1987

1987

ENTRIES
949 participants from 27 countries submitting 4,433 works

JURY
Dr. László Beke, curator, Hungarian National Gallery, Budapest
Elisabeth Dietz, art collector, Frankfurt am Main
Alain D'Hooghe, editor, *Clichés*, Brussels
Andreas Müller-Pohle, photographer and publisher, *European Photography*, Göttingen
Prof. Daniela Palazzoli, director, Academia Brera, Milan
Peter Weiermair, director, Frankfurter Kunstverein, Frankfurt am Main

PRIZEWINNERS
1st Prize: Thomas Florschuetz, Berlin
2nd Prize: Touhami Ennadre, Paris
3rd Prize: Marina Cox, Brussels

EXHIBITION
Frankfurter Kunstverein, Frankfurt am Main

PUBLICATION
"Young European Photographers '87", *European Photography*, Göttingen, nr. 32, 1988

1988

ENTRIES
906 participants from 26 countries submitting 4,263 works

JURY
Elisabeth Dietz, art collector, Frankfurt am Main
Christine Frisinghelli, editor, *Camera Austria*, Graz
Andreas Müller-Pohle, photographer and publisher, *European Photography*, Göttingen
Finn Thrane, director, Museet for Fotokunst, Odense
Ullrich Wallenburg, curator, Brandenburgische Kunstsammlungen, Cottbus
Peter Weiermair, director, Frankfurter Kunstverein, Frankfurt am Main

PRIZEWINNERS
1st Prize: Erwin Olaf, Amsterdam
2nd Prize: Henry Lewis, Paris
3rd Prize: Jens Rötzsch, Leipzig

EXHIBITIONS
Museum Ludwig, Cologne
FotoFest, Houston, Texas
Galerie Faber, Vienna

PUBLICATIONS
Young European Photographers. Contemporary Staged Photography from Europe, Bad Homburg: Deutsche Leasing AG, 1988 (FotoFest, Houston)
"Young European Photographers '88", *European Photography*, Göttingen, nr. 36, 1989

1989

ENTRIES
1,001 participants from 27 countries submitting 4,684 works

JURY
Dr. Erika Billeter, director, Musée Cantonal des Beaux-Arts, Lausanne
Dr. Ryszard Bobrowski, director, Galeria "Hybrydy", Warsaw
Elisabeth Dietz, art collector, Frankfurt am Main
Chantal Grande, director, Galeria Forvm, Tarragona
Andreas Müller-Pohle, photographer and publisher, *European Photography*, Göttingen
Peter Weiermair, director, Frankfurter Kunstverein, Frankfurt am Main

PRIZEWINNERS
1st Prize: Frédéric Marsal, Paris
2nd Prize: Marc Viaplana/Mabel Palacín, Barcelona
3rd Prize: Thomas Thys, Antwerp

EXHIBITIONS
Frankfurter Kunstverein, Frankfurt am Main
Stara Galeria, Warsaw
Galerie Foma, Prague
Sala Parpalló, Valencia

PUBLICATIONS
"Young European Photographers '89", *European Photography*, Göttingen, nr. 41, 1990
Young European Photographers, Bad Homburg: Deutsche Leasing AG, 1989 (Stara Galeria, Warsaw)
Young European Photographers, Bad Homburg: Deutsche Leasing AG, 1989 (Galerie Fotochema, Prague)
Jove Fotografia Europea. Valencia: Sala Parpalló, 1989

1990

ENTRIES
1,298 participants from 28 countries submitting 5,770 works

JURY
Matthias Dietz, Dietz Design Management, Frankfurt am Main
Alain D'Hooghe, editor, *Clichés*, Brussels
Jean-Claude Lemagny, curator, Bibliothèque Nationale, Paris
Daniela Mrázková, editor, *Fotografie*, Prague
Andreas Müller-Pohle, photographer and publisher, *European Photography*, Göttingen
Ullrich Wallenburg, curator, Brandenburgische Kunstsammlungen, Cottbus

PRIZEWINNERS
1st Prize: Dirk Braeckman, Ghent
2nd Prize: Hervé Charles, Obaix
3rd Prize: Lenni van Dinther, Aigaliers / Roman Muselík, Prague

EXHIBITION
Berlinische Galerie, Martin-Gropius-Bau, Berlin

PUBLICATION
"Young European Photographers '90", *European Photography*, Göttingen, nr. 45, 1991

1991

CURATORIAL BOARD / JURY
Monika Faber, Österreichisches Fotoarchiv, Vienna
Joan Fontcuberta, photographer and editor, *Photovision*, Barcelona
Mark Haworth-Booth, curator, Victoria & Albert Museum, London
Walter Keller, publisher, *Der Alltag*, Zürich
Jan-Erik Lundström, critic and curator, Båtvik
Daniela Mrázková, editor, *Fotografie*, Prague
Jean-Luc Monterosso, director, Paris Audiovisuel, Paris
Andreas Müller-Pohle, photographer and publisher, *European Photography*, Göttingen
Alain Sayag, curator, Centre Georges Pompidou, Paris
Hripsimé Visser, curator, Stedelijk Museum, Amsterdam

PRIZEWINNERS
1st Prize: Hannah Collins, Barcelona
2nd Prize: Leif Lindberg, Oslo
3rd Prize: Martí Llorens, Barcelona

EXHIBITION
Künstlerwerkstatt im Bahnhof Westend, Berlin

PUBLICATION
European Photography Award 1991. Göttingen: European Photography, 1991

1992

CURATORIAL BOARD / JURY
Carl Aigner, curator and editor, *Eikon*, Vienna
Dr. Antonín Dufek, curator, Moravská Galerie, Brno
Coen Eggen, Nederlands Fotomuseum, Sittard
Joan Fontcuberta, photographer and editor, *Photovision*, Barcelona
Sue Grayson Ford, director, The Photographers' Gallery, London
Barbara Kosinska, editor, *6x9*, Warsaw
Jean-Claude Lemagny, curator, Bibliothèque Nationale, Paris
Andreas Müller-Pohle, photographer and publisher, *European Photography*, Göttingen
Pirkko Siitari, director, Nordic Center of Photography, Oulu
Roberta Valtorta, critic and curator, Milan

PRIZEWINNERS
1st Prize: Eva Schlegel, Vienna
2nd Prize: Mikolaj Smoczynski, Lublin
3rd Prize: Erasmus Schröter, Hamburg

EXHIBITIONS
Künstlerwerkstatt im Bahnhof Westend, Berlin
Kulturzentrum Englische Kirche, Bad Homburg v.d.H.

PUBLICATION
European Photography Award 1992. Göttingen: European Photography, 1992

1993

PRIZEWINNERS
1st Prize: Henrik Duncker / Yrjö Tuunanen,
Helsinki
2nd Prize: Anna Fox, London
3rd Prize: Beat Streuli, Düsseldorf

EXHIBITION
Kulturzentrum Englische Kirche, Bad
Homburg v.d.H.

PUBLICATION
European Photography Award 1993. Göttingen:
European Photography, 1993